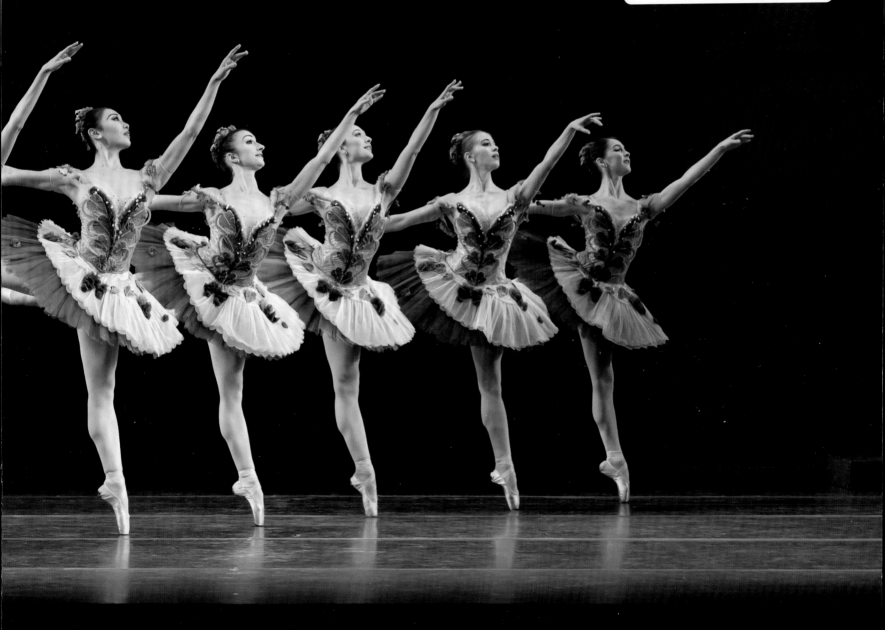

Supported using public funding by
ARTS COUNCIL ENGLAND
LOTTERY FUNDED

Cover: The Royal Ballet in Crystal Pite's *Flight Pattern* ©ROH 2017. Photograph by Tristram Kenton

Inside front cover: Camille Bracher, Romany Pajdak, Leticia Stock, Mariko Sasaki, Gemma Pitchley-Gale, Mica Bradbury, Estelle Bovay and Ashley Dean in *The Sleeping Beauty* ©ROH 2016. Photograph by Bill Cooper

Inside back cover: The Royal Ballet in Wayne McGregor's *Multiverse* ©ROH 2016. Photograph by Andrej Uspenski

First published in 2017 by the Royal Opera House
in association with Oberon Books Ltd
Oberon Books Ltd
521 Caledonian Road, London N7 9RH
Tel +44 (0)20 7607 3637
info@oberonbooks.com
www.oberonbooks.com

Compilation copyright © Royal Opera House 2017

Text copyright © Royal Opera House 2017

Design: Konstantinos Vasdekis

For the Royal Opera House:

Editor: Will Richmond

Project Manager: Alice Jones

Every effort has been made to trace the copyright holders of all images reprinted in this book. Acknowledgement is made in all cases where the image source is available, but we would be grateful for information about any images where sources could not be traced.

A catalogue record for this book is available from the British Library.

PB ISBN 9781786822895

Printed and bound by
CPI Group (UK) Ltd, Croydon, CR0 4YY

Royal Opera House
Covent Garden
London WC2E 9DD
Box Office +44 (0)20 7304 4000
www.roh.org.uk

ROYAL
BALLET

2017/18

THE 2017/18 ROYAL BALLET YEARBOOK AND ROYAL BALLET SEASON GENEROUSLY SUPPORTED BY
AUD JEBSEN

THE 2017/18 SEASON

WELCOME TO THE 2017/18 SEASON, FROM KEVIN O'HARE

A special highlight of the Season is our tribute to the genius of master choreographer Kenneth MacMillan, which marks the 25th anniversary of his death. His seminal works shaped not only the direction of the Company's history but also the very substance of ballet in the 20th century. In honour of his impact on the art form we are delighted to welcome five other ballet companies to the Royal Opera House stages for **Kenneth MacMillan: a National Celebration**, some of them performing here for the very first time. Bringing the companies together under one roof will make the October moment an exciting one. Our dancers will join forces to show the adventurous range of Kenneth's compelling canon of work: including **Concerto** (performed by Birmingham Royal Ballet), **Song of the Earth** (English National Ballet), **Gloria** (Northern Ballet), **The Judas Tree** (The Royal Ballet), **Le Baiser de la fée** (Scottish Ballet) and **Elite Syncopations** (The Royal Ballet and soloists from the guest companies).

The celebrations also include another MacMillan masterpiece, **Manon**, which will be performed later in the Season. Others of MacMillan's works will be presented in the Clore Studio Upstairs and a series of Insight evenings will explore his legacy and genius.

A contrasting aspect of our heritage is displayed in the work of our Founder Choreographer Frederick Ashton. This Season will bring a revival of the pastoral love story **Sylvia** and the impassioned **Marguerite and Armand**. Essential classics **The Nutcracker** and **Giselle** also return as well as more recent favourites, **Alice's Adventures in Wonderland** and **The Winter's Tale** by The Royal Ballet's Artistic Associate Christopher Wheeldon. Christopher also choreographs a new ballet for a mixed programme marking the centenary of Leonard Bernstein's birth. Also in this **Bernstein Centenary** celebration will be a new work by Resident Choreographer Wayne McGregor, a co-production with Dutch National Ballet, set to Bernstein's glorious choral score *Chichester Psalms*, and the first revival of Artist in Residence Liam Scarlett's **The Age of Anxiety**, danced to Bernstein's musical setting of W.H. Auden's poem.

New work is at the fore in another mixed programme this Season. We are thrilled to welcome American dance luminary Twyla Tharp to create **The Illustrated 'Farewell'**, a new work for the Company set to Haydn's 'Farewell' Symphony. Twyla's new work will be performed alongside a new ballet by Arthur Pita – **The Wind** – his first work for the main stage. The dramatic flair Arthur brought to his award-winning dance theatre piece *The Metamorphosis* will be put to exciting use interpreting Dorothy Scarborough's seminal work of Texan fiction and one of the great classics of the silent movie era.

Other atmospheric one-act ballets returning to the stage are Wayne McGregor's **Obsidian Tear** (from 2016) and Hofesh Shechter's **Untouchable** (from 2015).

The final highlight of our Season is the 19th-century Petipa/Ivanov classic **Swan Lake**, set to Tchaikovsky's sublime score. We look forward to seeing this beloved ballet in a new staging with additional choreography by Liam Scarlett. John Macfarlane continues his long association with The Royal Ballet as designer of this new production.

I hope you will find an abundance of choice for the 2017/18 Season.

Kevin O'Hare
Director, The Royal Ballet

This page:
Twyla Tharp,
Arthur Pita
Opposite page:
Kenneth
MacMillan
©Roy Round

THE 2017/18 SEASON AT A GLANCE

NOVEMBER–DECEMBER

SYLVIA
Choreography Frederick Ashton
Production Christopher Newton
Music Léo Delibes
Original designers Christopher Ironside and Robin Ironside
Additional designs Peter Farmer
Lighting designer Mark Jonathan

Premiere
3 September 1952
(Sadler's Wells Ballet)

NOUMENA
Choreography Alexander Whitley
Music Bryce Dessner
Costume designer Ilaria Martello
Light installation
Children of the Light
Lighting designer Guy Hoare
Musicians The 12 Ensemble

Premiere
23 November 2017
(Alexander Whitley Dance Company)

DECEMBER 2017–JANUARY 2018

THE NUTCRACKER
Choreography Peter Wright
after Lev Ivanov
Music Pyotr Ilyich Tchaikovsky
Original scenario Marius Petipa
Production and scenario Peter Wright
Designer Julia Trevelyan Oman
Lighting designer Mark Henderson
Production consultant
Roland John Wiley

Premieres
1892
(Mariinsky Theatre, St Petersburg)

20 December 1984
(The Royal Ballet, this production)

2018

JANUARY–MARCH

GISELLE
Choreography Marius Petipa after Jean Coralli and Jules Perrot
Music Adolphe Adam
Scenario Théophile Gautier after Heinrich Heine
Production Peter Wright

Additional choreography
Peter Wright
Designer John Macfarlane
Original lighting Jennifer Tipton
Lighting re-created by David Finn

Premieres
28 June 1841 (Paris: original choreography by Jean Coralli and Jules Perrot; later versions by Petipa, notably 1884)

1 January 1934
(Vic-Wells Ballet)

28 November 1985
(The Royal Ballet, this production)

FEBRUARY–MARCH

THE WINTER'S TALE
Choreography Christopher Wheeldon
Scenario Christopher Wheeldon and Joby Talbot
Music Joby Talbot
Designer Bob Crowley
Lighting designer Natasha Katz
Projection designer Daniel Brodie
Silk effects designer Basil Twist

Premiere
10 April 2014
(The Royal Ballet)

MARCH–APRIL

BERNSTEIN CENTENARY

NEW WAYNE MCGREGOR
Choreography Wayne McGregor
Music Leonard Bernstein
Designer Edmund de Waal
Lighting designer Lucy Carter

Premiere
15 March 2018
(The Royal Ballet)

THE AGE OF ANXIETY
Choreography Liam Scarlett
Music Leonard Bernstein
Designer John Macfarlane
Lighting Jennifer Tipton

Premiere
7 November 2014
(The Royal Ballet)

NEW CHRISTOPHER WHEELDON
Choreography Christopher Wheeldon
Music Leonard Bernstein
Set designer Jean-Marc Puissant
Costume designer Erdem Moralioglu
Lighting designer Peter Mumford

Premiere
15 March 2018
(The Royal Ballet)

MARCH–MAY

MANON
Choreography Kenneth MacMillan
Music Jules Massenet
Orchestration Martin Yates
Designer Nicholas Georgiadis
Lighting designer John B. Read

Premiere
7 March 1974
(The Royal Ballet)

APRIL–MAY

OBSIDIAN TEAR/MARGUERITE AND ARMAND/ELITE SYNCOPATIONS

OBSIDIAN TEAR
Choreography Wayne McGregor
Music Esa-Pekka Salonen
Set designer Wayne McGregor
Fashion director Katie Shillingford
Lighting designer Lucy Carter
Dramaturgy Uzma Hameed

Premiere
28 May 2016
(The Royal Ballet)

MARGUERITE AND ARMAND
Choreography Frederick Ashton
Music Franz Liszt
Orchestration Dudley Simpson
Designer Cecil Beaton
Lighting designer John B. Read

Premiere
12 March 1963
(The Royal Ballet)

MAY–JUNE

SWAN LAKE
Choreography Marius Petipa and Lev Ivanov
Additional choreography
Liam Scarlett and Frederick Ashton
Music Pyotr Ilyich Tchaikovsky
Production Liam Scarlett
Designer John Macfarlane
Lighting designer David Finn

Premiere
17 May 2018
(The Royal Ballet)

COMPANY NEWS AND PROMOTIONS

ZENAIDA YANOWSKY BY PAUL KILBEY

After 23 years including 16 as a Principal, Zenaida Yanowsky retired from The Royal Ballet at the end of the 2016/17 Season. Her final Company performance in London was in *Marguerite and Armand*, dancing the lead opposite Guest Artist Roberto Bolle.

A versatile dancer of piercing intelligence, Yanowsky has long excelled in diverse repertory. Memorable recent role creations – the Queen of Hearts in *Alice's Adventures in Wonderland*, Paulina in *The Winter's Tale*, the title role in *Elizabeth* – complement earlier creations for such choreographers as Christopher Bruce and Ashley Page. Equally strong in Royal Ballet heritage roles from Ashton's Natalia Petrovna to MacMillan's Manon, she also danced a famed Odette/Odile, and performed with exquisite power in *Les Noces* and *The Rite of Spring*.

Born to two ballet dancer parents – the Russian Anatol Yanowsky and the Spanish Carmen Robles were both dancing for Lyons Opera Ballet when Zenaida was born in 1974 – she and two of her three siblings chose to follow the family career path, although the teenage Zenaida was also tempted by painting and singing. After winning silver at Varna in 1991, she joined the Paris Opera Ballet, but further competition success (gold at the 1993 Eurovision Young Dancer and the 1994 Jacksonville competitions) prompted her towards a change of company. She was invited by Anthony Dowell to join The Royal Ballet as a First Artist in 1994, and became a Principal in 2001.

Yanowsky has always had an inimitable physical presence. Tall and commanding on stage, she is not in the diminutive Fonteynian image more commonly associated with The Royal Ballet. But it is a measure of her talent that she has made so many Company roles her own – not just Marguerite and Manon, but also Sylvia, a role (like Marguerite) conceived for Fonteyn. When *Sylvia* was staged in 2004 and 2008, Yanowsky's performances were wonderfully received, even called 'the definitive Sylvia' by one critic. And it is telling that she chose to make her final Covent Garden appearance as Marguerite, another classic Company role to which she has brought her own personality, while retaining the essence of the character and the choreography.

Contemporary choreographers have long been inspired by Yanowsky. Immediately on arriving in 1994, she was cast in the first revival of Ashley Page's *Fearful Symmetries*. She has been closely associated with Will Tuckett for many years, having created roles with him including in *Proverb*, *The Seven Deadly Sins* and *Elizabeth*, for which she won a National Dance Award in 2016. They have collaborated many times outside the Royal Opera House as well. And her work with Christopher Wheeldon has ranged from *DGV: Danse à grande vitesse* and *Electric Counterpoint* to key roles in both his full-length Company creations: *Alice's Adventures in Wonderland* and *The Winter's Tale*. The Queen of Hearts is an explosive comic cameo, while Paulina is an enthralling and subtle character role – yet both these expertly crafted creations will remain indelibly associated with Yanowsky in the years to come.

Royal Ballet Director Kevin O'Hare, Company members past and present and the cast of *Marguerite and Armand* congratulate Zenaida Yanowsky on her final performance. ©2017 ROH. Photograph by Alastair Muir

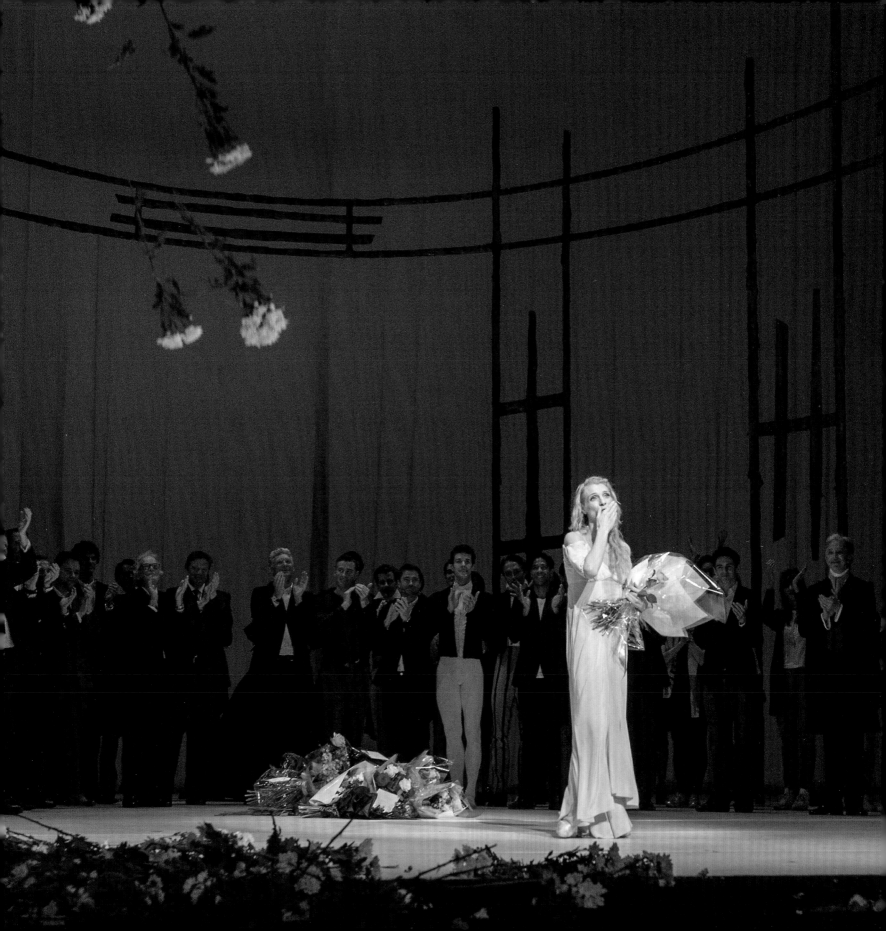

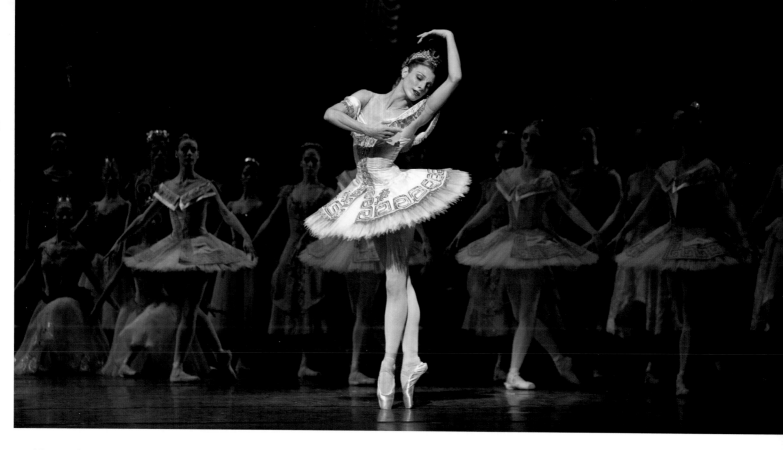

This page: Zenaida Yanowksy as Sylvia in Act III of *Sylvia* ©ROH/Bill Cooper, 2004

Marguerite and Armand was not the only high point in her final few months with The Royal Ballet. She created two new roles, for Liam Scarlett (*Symphonic Dances*) and Javier De Frutos (*Les Enfants Terribles*), and she also reprised the role of the Empress in *Mayerling* – a great role for her peerless acting talents – as well as the emotive pas de deux in Wheeldon's *After the Rain*. Her final performances as a Company member were on tour in Brisbane, performing Paulina.

Thankfully, Yanowsky is not finished with her performing career. Her interpretative gifts remain unique. In a recent *Dancing Times* interview, she compared dancing choreography to translation: 'how can I translate it into my words, as if they were my words to the audience. Because they are words, the steps are words. If you treat them like words, you will then understand the rhythm of the phrasing. It will become a play. That's what I'm after.'

MATTHEW GOLDING

Matthew Golding also left The Royal Ballet at the end of the Season, after three years as a Principal dancer. He joined The Royal Ballet as a Principal in January 2014, having danced Solor (*La Bayadère*) with the Company the previous Season as a Guest. His many Royal Ballet roles included Albrecht (*Giselle*), Basilio and Espada (*Don Quixote*), Prince Florimund (*The Sleeping Beauty*), Prince Siegfried (*Swan Lake*), Eugene Onegin, Oberon (*The Dream*), Romeo, Des Grieux (*Manon*), roles in Wheeldon's *Within the Golden Hour* and *DGV: Danse à grande vitesse* and Balanchine's *Tchaikovsky Pas de deux*, *Serenade* and *The Four Temperaments* . He created roles in Liam Scarlett's *Summertime* and Carlos Acosta's *Carmen*.

Director Kevin O'Hare said, 'Matthew gave many fine performances during his time with The Royal Ballet and danced a number of leading roles from across our repertory. We wish him well for the next stage of his performing career.'

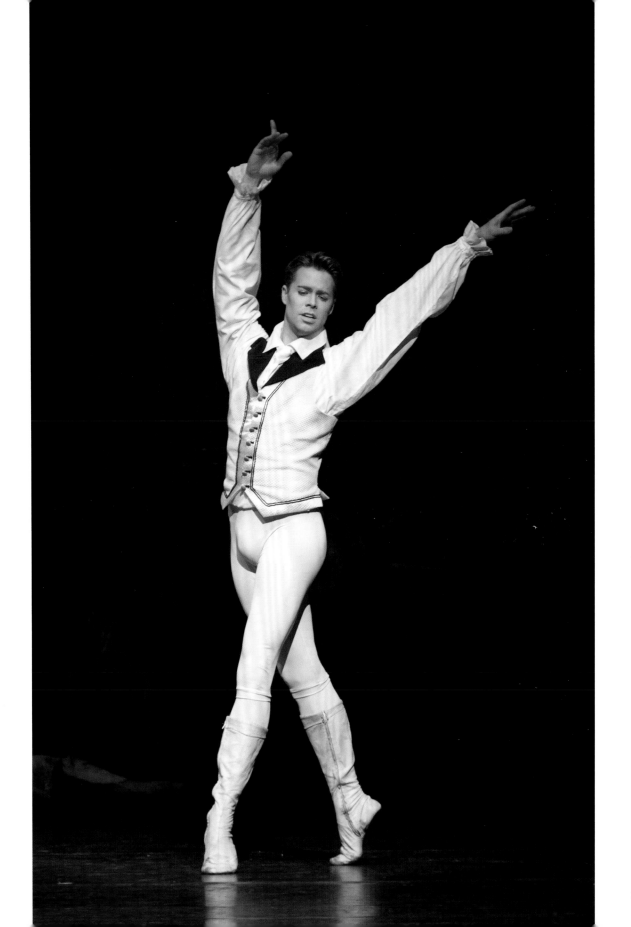

This page:
Matthew
Golding as
Des Grieux
in *Manon*
©ROH 2014.
Photograph
by Alice
Pennefather

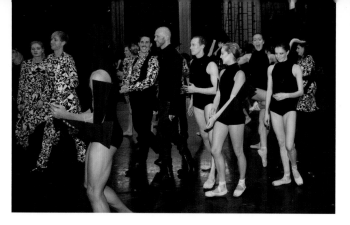
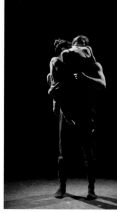

OTHER NEWS

Every Royal Ballet Season brings a rich diversity of new works, new additions to the repertory, revivals, heritage works and classical ballets. The 2016/17 Season was also full of celebrations.

The December–March performances of *The Sleeping Beauty* celebrated 70 years since The Royal Ballet became resident at the Royal Opera House – the ballet has a special place in the Company's heritage, as the first work to be performed in 1946 to reopen the building after World War II.

Performances of *Jewels* in March celebrated 50 years since George Balanchine created this showpiece ballet.

The Company celebrated another anniversary: 10 years since Wayne McGregor was made Resident Choreographer. The November mixed programme marked McGregor's decade with The Royal Ballet, featuring *Chroma* (from 2006) and *Carbon Life* (2012). The cast of *Chroma* was split between Royal Ballet dancers and dancers from Alvin Ailey American Dance Theater; Mark Ronson returned to perform his music for *Carbon Life* with many of the original artists – both ballets demonstrate McGregor's innovation and unique collaborative style. McGregor's new ballet, *Multiverse*, completed the programme, with groundbreaking designs by artist Rashid Rana and newly-commissioned music from Steve Reich. An Insight event, live streamed online, saw McGregor in conversation with the ballet's dramaturg Uzma Hameed and Royal Ballet Music Director Koen Kessels, while McGregor also rehearsed Steven McRae, Francesca Hayward and Paul Kay for their roles.

Other new work during the Season reflected McGregor's nurturing and developing of young choreographers over the last decade, with the annual programme of 'Draft Works', which included pieces by Lukas Bjørneboe Brændsrød, Charlotte Edmonds, Sian Murphy, Calvin Richardson, Joseph Sissens and former Royal Ballet dancer Vanessa Fenton. A mixed programme in the Clore Studio Upstairs also showed new short works by Charlotte Edmonds and Robert Binet: *Meta* and *Void and Fire*. Former Royal Ballet Principal Alessandra Ferri returned to perform the role McGregor created on her in *Woolf Works*, and former Principal Mara Galeazzi, who left the Company in 2013, shared the performances with her.

Former Principal Roberta Marquez, who retired during the 2015/16 Season after 11 years with the Company returned for two farewell performances as Lise in Ashton's *La Fille mal gardée*, one of her signature roles as a Principal. She was partnered by Alexander Campbell as Colas.

Peter Wright, whose productions of *The Nutcracker* and *Giselle* are among the most popular in the Company's repertory, celebrated his 90th birthday during the 2016/17 Season. Following a performance of *The Nutcracker* in December, Wright joined the dancers on stage with Director Kevin O'Hare, and Company members past and present.

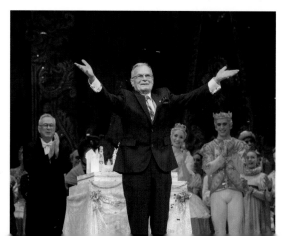
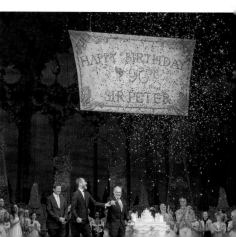

Six performances were relayed live to audiences all over the world as part of the Royal Opera House Live Cinema Season: *Anastasia*, *The Nutcracker*, *Woolf Works*, *The Sleeping Beauty*, *Jewels* and the Ashton mixed programme.

In June the Company toured to Australia, giving performances of *Woolf Works* and Christopher Wheeldon's *The Winter's Tale* at the Lyric Theatre, Queensland Performing Arts Centre (QPAC) in Brisbane, as well as at the Munro Martin Parklands in Cairns, where the Company presented a gala performance.

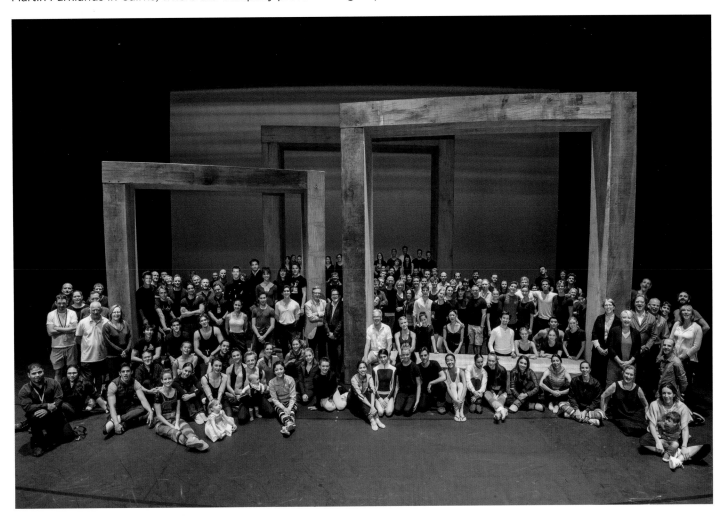

This page: The Royal Ballet on the *Woolf Works* set at the QPAC in Brisbane ©Darren Thomas

Opposite page: (*from top left*) The cast of this Season's celebratory performances of McGregor's *Chroma*, from The Royal Ballet and Alvin Ailey American Dance Theater: Yannick Lebrun, Luca Acri, Federico Bonelli, Sarah Lamb, Lauren Cuthbertson, Rachael McLaren, Jamar Roberts, Jacqueline Green, Calvin Richardson and Solomon Dumas ©ROH 2017. Photograph by Andrej Uspenski

Wayne McGregor backstage after the first performance of *Carbon Life*, with members of the cast and musicians; McGregor cutting his celebratory cake ©ROH 2016. Photographs by Andrej Uspenski

Kristen McNally and Thomas Whitehead in Sian Murphy's Draft Work ©ROH 2017. Photograph by Alice Pennefather

Roberta Marquez's flow-throw after her guest performance as Lise in *La Fille mal gardée* ©ROH 2016. Photograph by Andrej Uspenski

Peter Wright on stage to celebrate his 90th birthday ©ROH 2016. Photograph by Andrej Uspenski

PROMOTIONS AND NEW MEMBERS

For the 2017/18 Season First Soloist **Yasmine Naghdi** is promoted to Principal.

Christina Arestis, **Bennet Gartside**, **Kristen McNally** and **Thomas Whitehead** are promoted to Principal Character Artist.

Soloists **Matthew Ball** and **Marcelino Sambé** are promoted to First Soloist. First Artists **Reece Clarke**, **Benjamin Ella** and **Anna Rose O'Sullivan** are promoted to Soloist. Artists **Hannah Grennell**, **Calvin Richardson**, **Gina Storm-Jensen** and **David Yudes** are promoted to First Artist.

William Bracewell joins the Company as a Soloist from Birmingham Royal Ballet.

For the 2017/18 Season three of the 2016/17 Aud Jebsen Young Dancers – **Giacomo Rovero**, **Francisco Serrano** and **Charlotte Tonkinson** – join the Company as Artists.

Stanisław Węgrzyn joins the Company as Prix de Lausanne dancer for the 2017/18 Season.

First Soloist **Melissa Hamilton** returns to the Company after a leave of absence performing with Semperoper Dresden.

Principal dancer **Zenaida Yanowsky** leaves The Royal Ballet after 23 years with the Company.

Matthew Golding leaves the Company after three years as Principal.

First Soloist **Valeri Hristov** leaves to join the artistic teaching faculty at The Royal Ballet School after 15 years with the Company.

First Soloist **Johannes Stepanek** retires after 17 years with The Royal Ballet to progress a new career within opera and dance.

Soloist **Eric Underwood** left The Royal Ballet in August 2017 after 11 years in the Company.

First Artist **Hayley Forskitt** retires from dance and Artist **Solomon Golding** leaves to join San Francisco Ballet.

 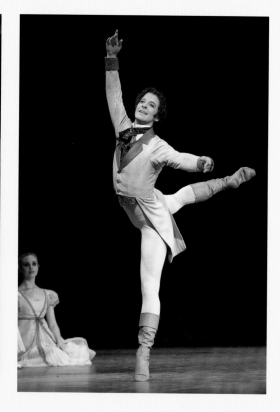

This page: (*left to right*) Eric Underwood in Wayne McGregor's *Infra* ©ROH/Bill Cooper, 2010
Valeri Hristov in MacMillan's *Elite Syncopations* ©Johan Persson, 2010
Johannes Stepanek in Cranko's *Onegin* ©ROH/Bill Cooper, 2010

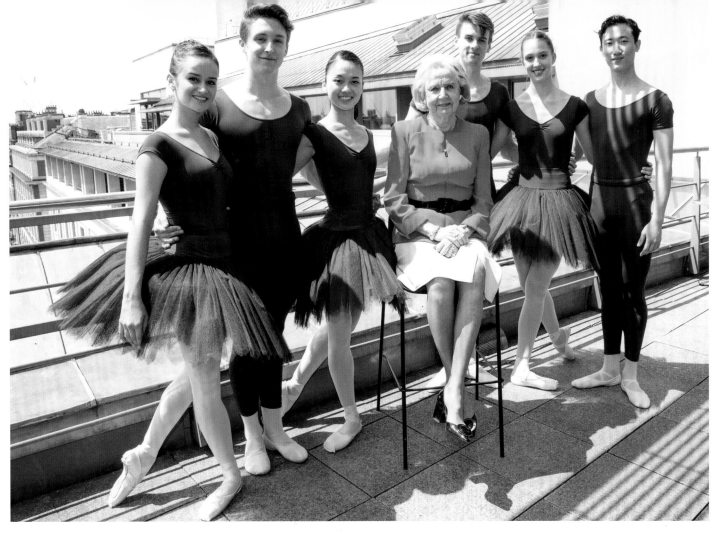

Aud Jebsen with (*left to right*) Amelia Palmiero, Joshua Junker, Sae Maeda, Aiden O'Brien, Nadia Mullova-Barley and Joonhyuk Jun ©ROH 2016. Photograph by Andrej Uspenski

AUD JEBSEN YOUNG DANCERS PROGRAMME

The Aud Jebsen Young Dancers Programme was inaugurated at the start of the 2014/15 Season to offer a handful of young dancers the opportunity of a year's contract to rehearse and perform with The Royal Ballet.

Each Season the group of recent graduates from The Royal Ballet School, as part of their transition from students to professional dancers, are given the unique experience of training with the corps de ballet and receive mentoring and coaching from the Company's resident and guest teachers.

Many have graduated from the Programme into the ranks of The Royal Ballet, and for others the Programme has led to contracts with other leading ballet companies.

Of last Season's Young Dancers, Giacomo Rovero, Francisco Serrano and Charlotte Tonkinson all joined The Royal Ballet as Artists for the 2017/18 Season, while Arianna Maldini joined the Bayerisches Staatsballett as a Soloist, Maria Castillo Yoshida joined Ballet De Catalunya, Spain and Estelle Bovay joined NDT 2.

This Season the programme welcomes its fourth group of dancers: Joonhyuk Jun, Joshua Junker, Sae Maeda, Nadia Mullova-Barley, Aiden O'Brien and Amelia Palmiero. All of them had a taste of dancing with the Company during their time at the School, whether in the ballroom scenes for *Anastasia* and *Mayerling*, as ladies and gentleman of the Court in *The Sleeping Beauty*, or as Snowflakes in *The Nutcracker*.

They will spend their year with the Company taking class, rehearsing the Season's repertory, including classics, heritage works and new works by resident, associate and visiting choreographers, and participating in performances on stage.

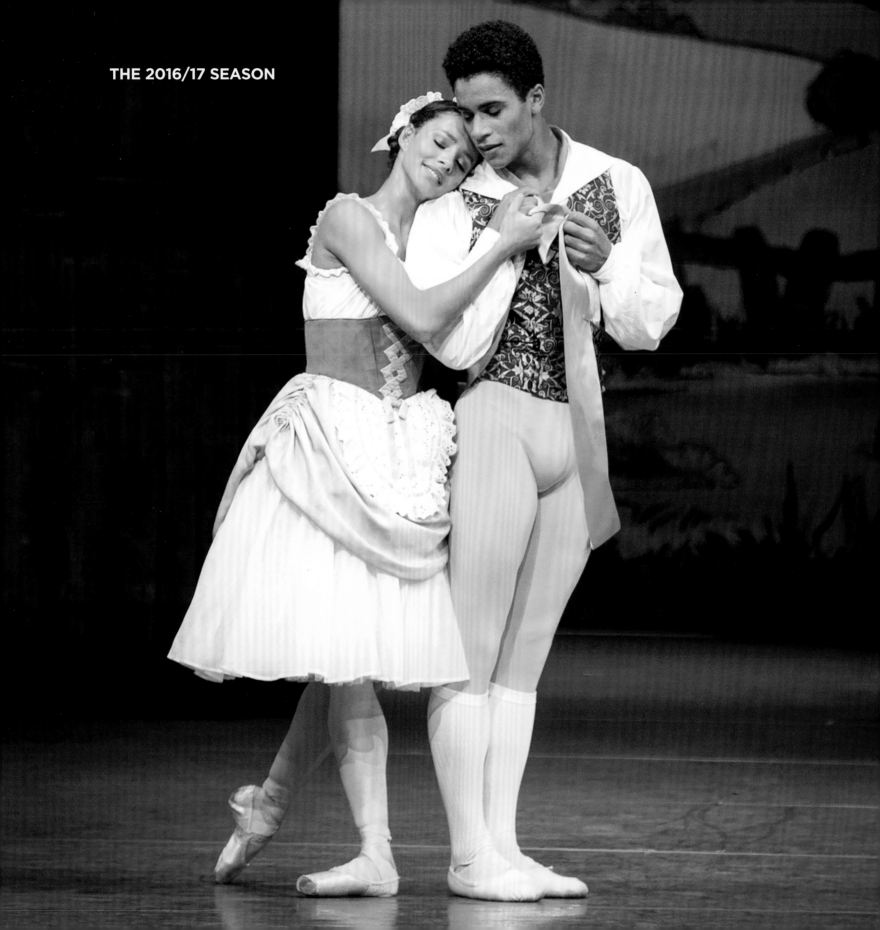

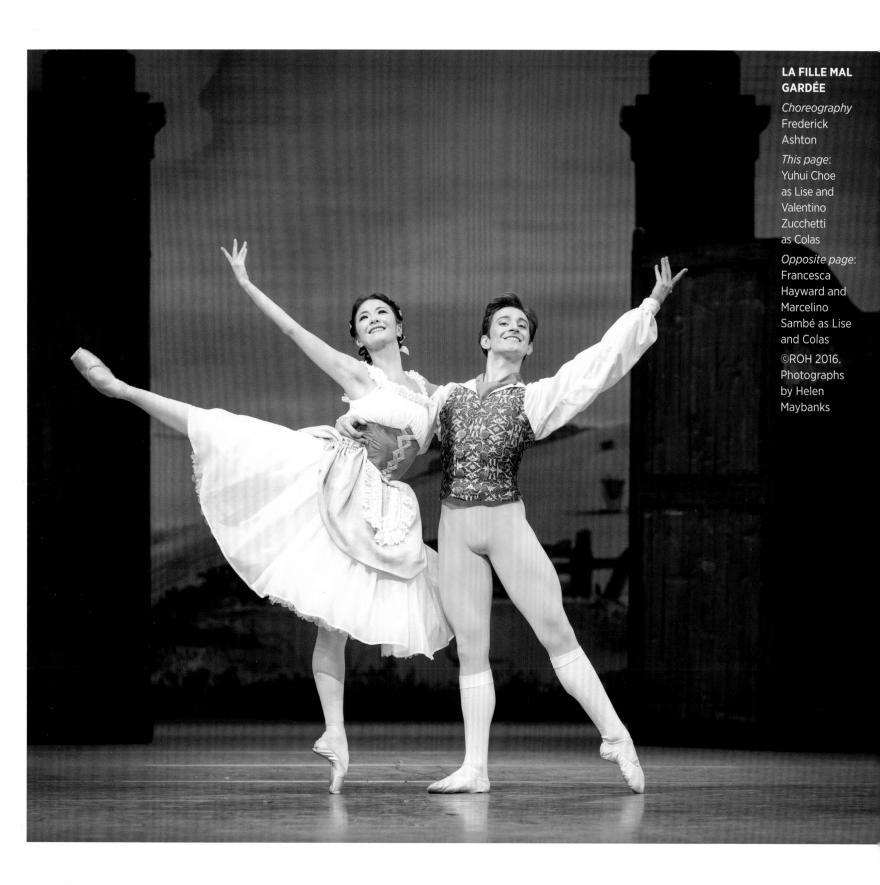

LA FILLE MAL GARDÉE

Choreography
Frederick Ashton

This page:
Yuhui Choe
as Lise and
Valentino
Zucchetti
as Colas

Opposite page:
Francesca
Hayward and
Marcelino
Sambé as Lise
and Colas

©ROH 2016.
Photographs
by Helen
Maybanks

ANASTASIA

Choreography
Kenneth
MacMillan

This page:
Natalia
Osipova as
Grand Duchess
Anastasia

Opposite page:
Marianela
Nuñez and
Federico
Bonelli as
Mathilde
Kschessinska
and her
Partner

©ROH 2016.
Photographs
by Tristram
Kenton

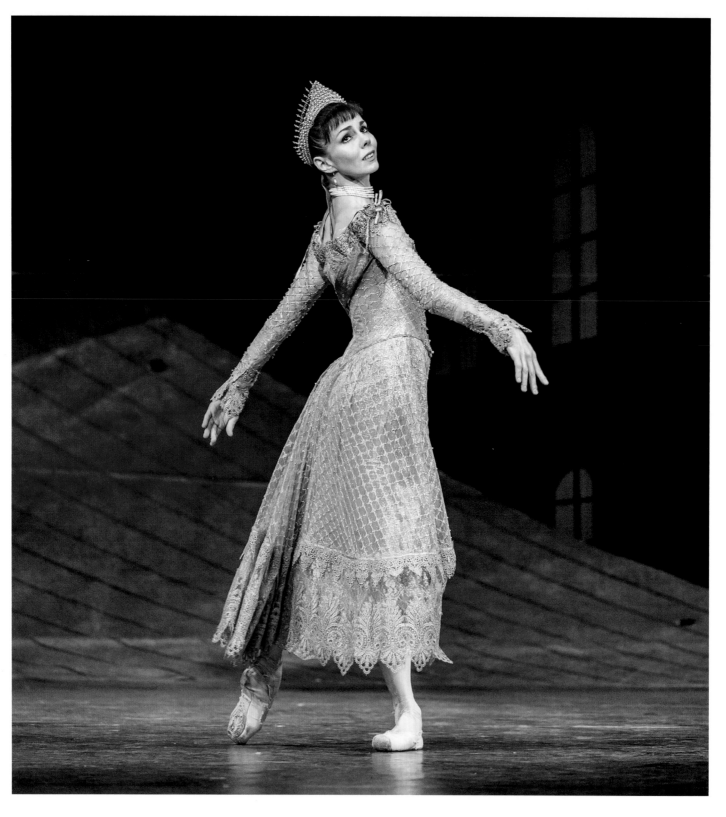

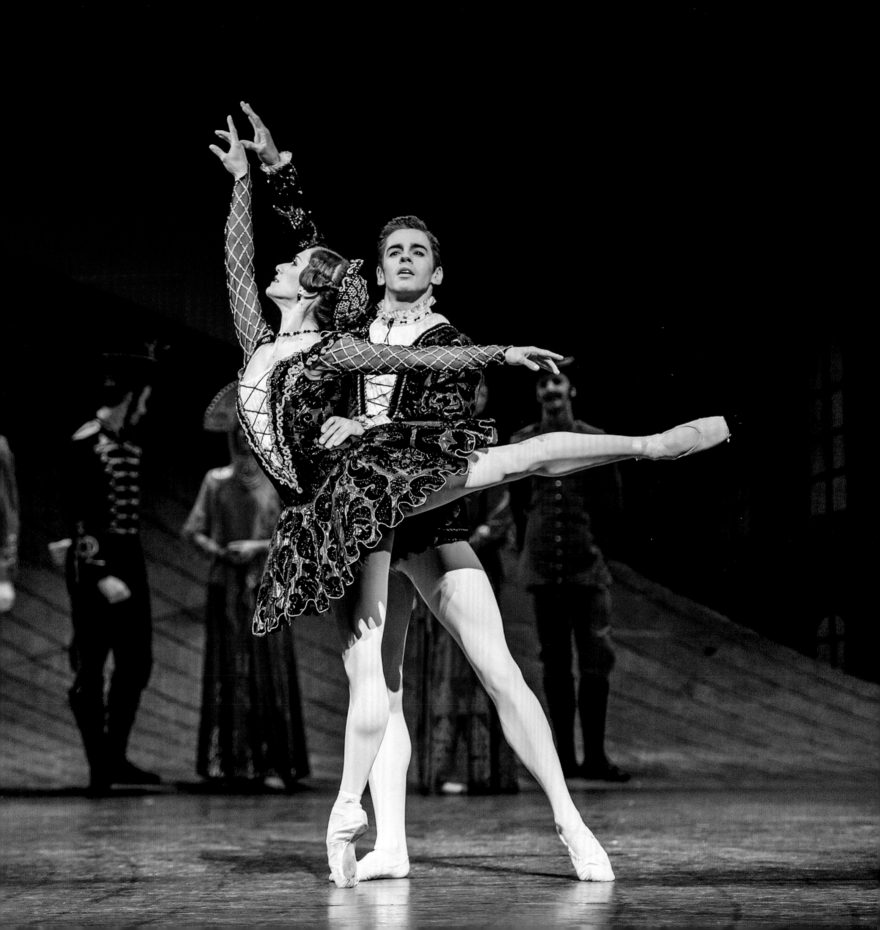

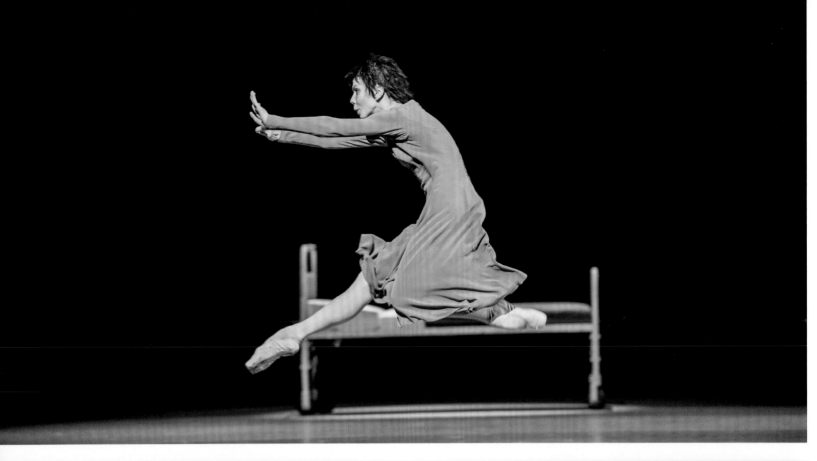

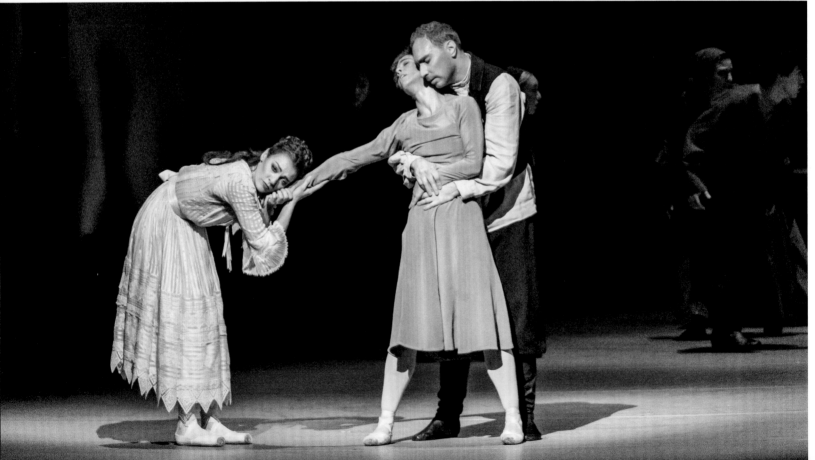

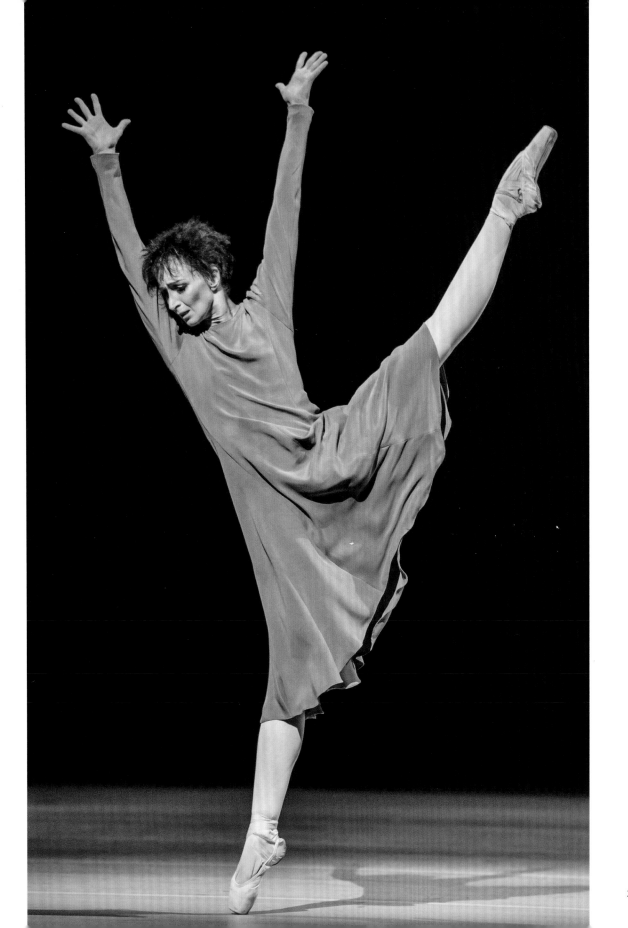

This page:
Lauren
Cuthbertson
as Anna
Anderson

Opposite page:
(*top*) Natalia
Osipova
as Anna
Anderson;
(*bottom*)
Laura Morera
as Anna
Anderson with
Helen Crawford
and Bennet
Gartside

©ROH 2016.
Photographs
by Tristram
Kenton

CHROMA

Choreography
Wayne
McGregor

This page:
Rachael
McLaren (Alvin
Ailey American
Dance Theater)
and Steven
McRae

*Opposite
page*: Lauren
Cuthbertson
and Jamar
Roberts (Alvin
Ailey American
Dance Theater)

©ROH 2016.
Photographs
by Andrej
Uspenski

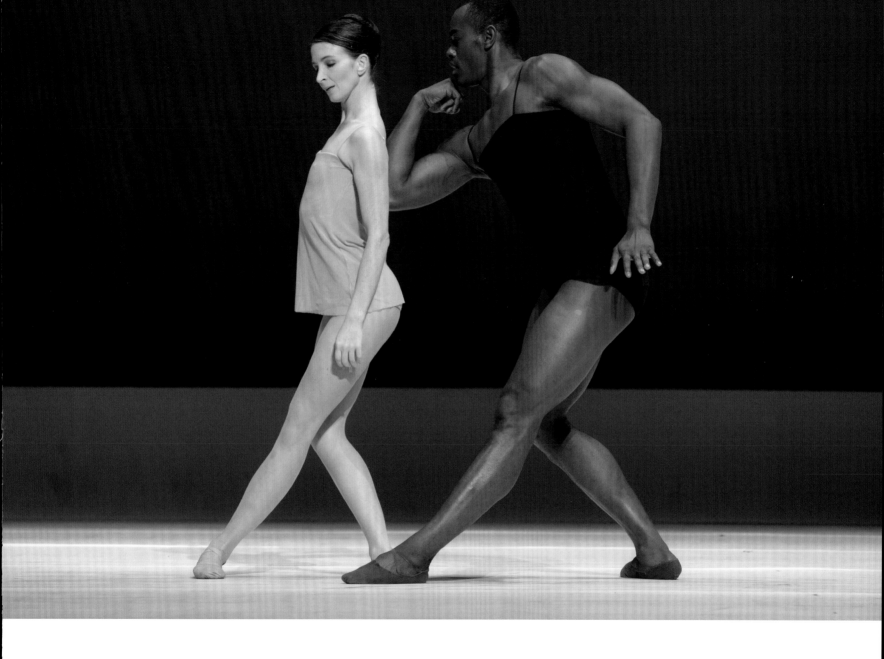

This page:
Jacqueline Green and Solomon Dumas (Alvin Ailey American Dance Theater)

Opposite page:
Artists of The Royal Ballet and Alvin Ailey American Dance Theater ©ROH 2016. Photographs by Andrej Uspenski

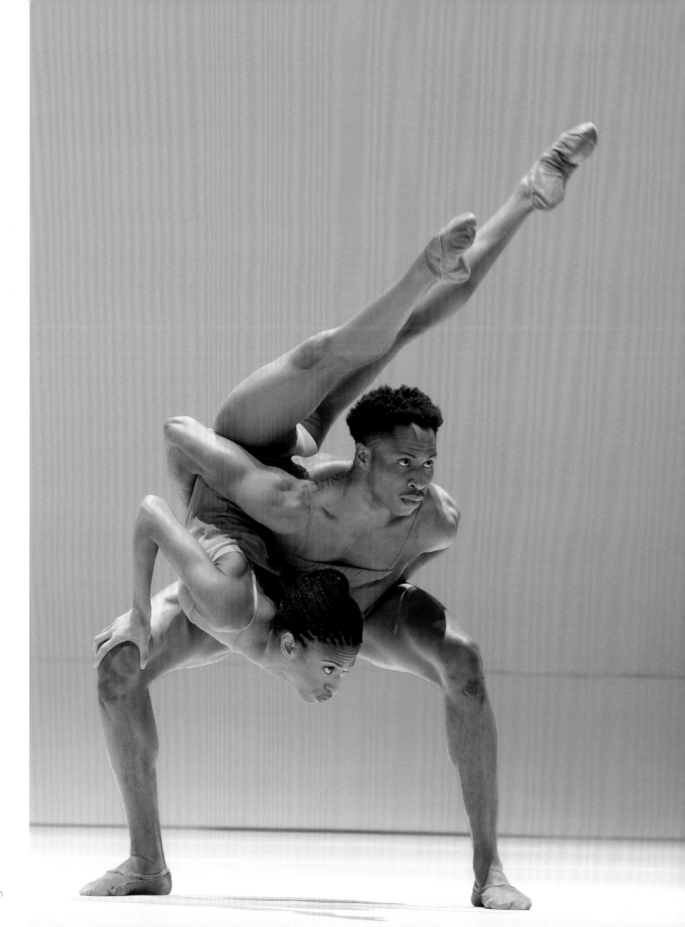

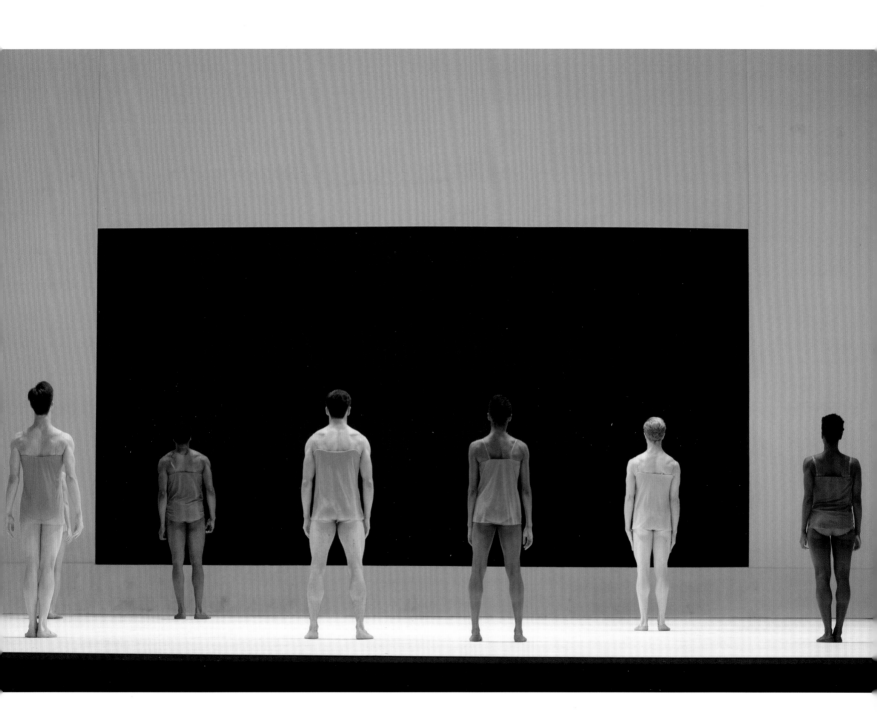

MULTIVERSE

Choreography
Wayne
McGregor

This page:
Marianela
Nuñez, Steven
McRae,
Francesca
Hayward
and Federico
Bonelli

Opposite page:
Sarah Lamb,
Paul Kay and
Matthew Ball
©ROH 2016.
Photographs
by Andrej
Uspenski

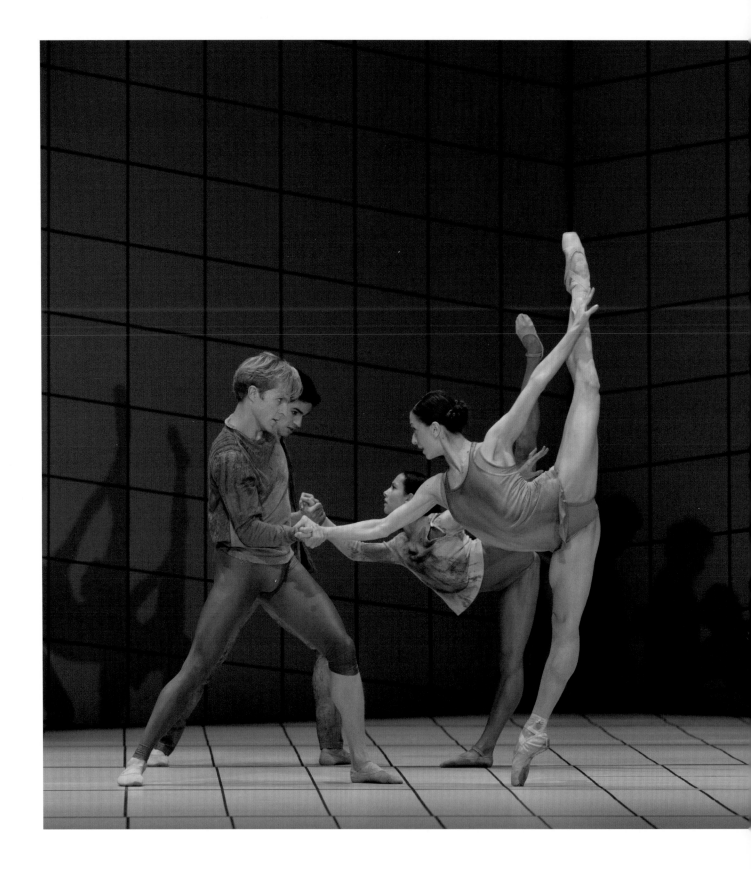

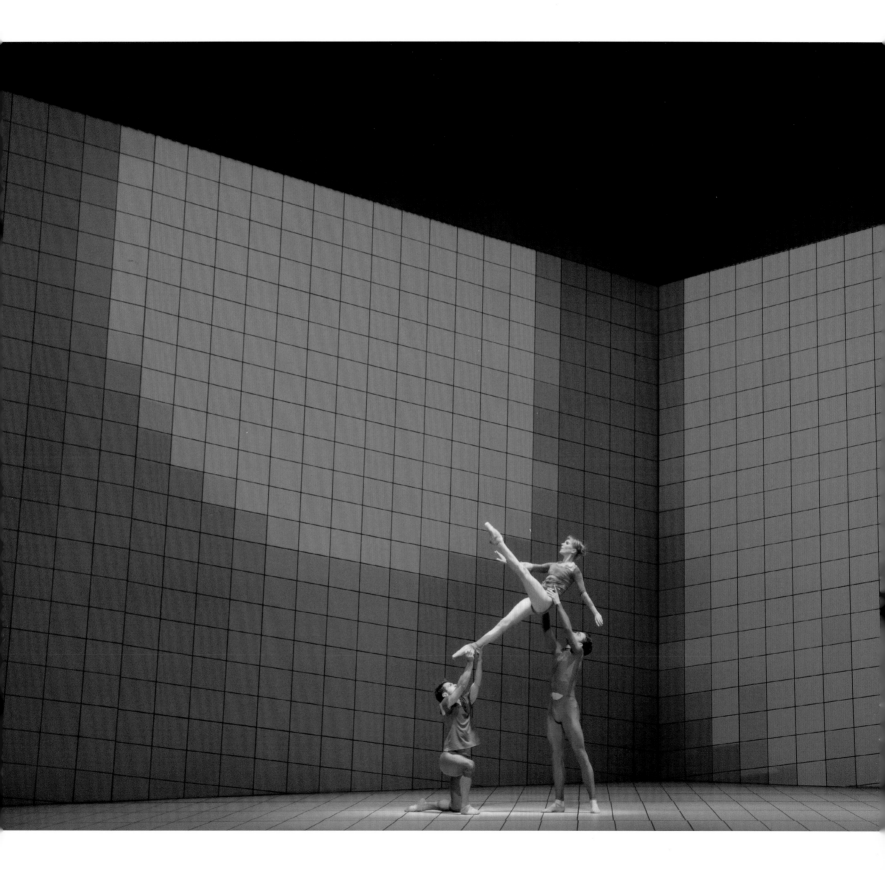

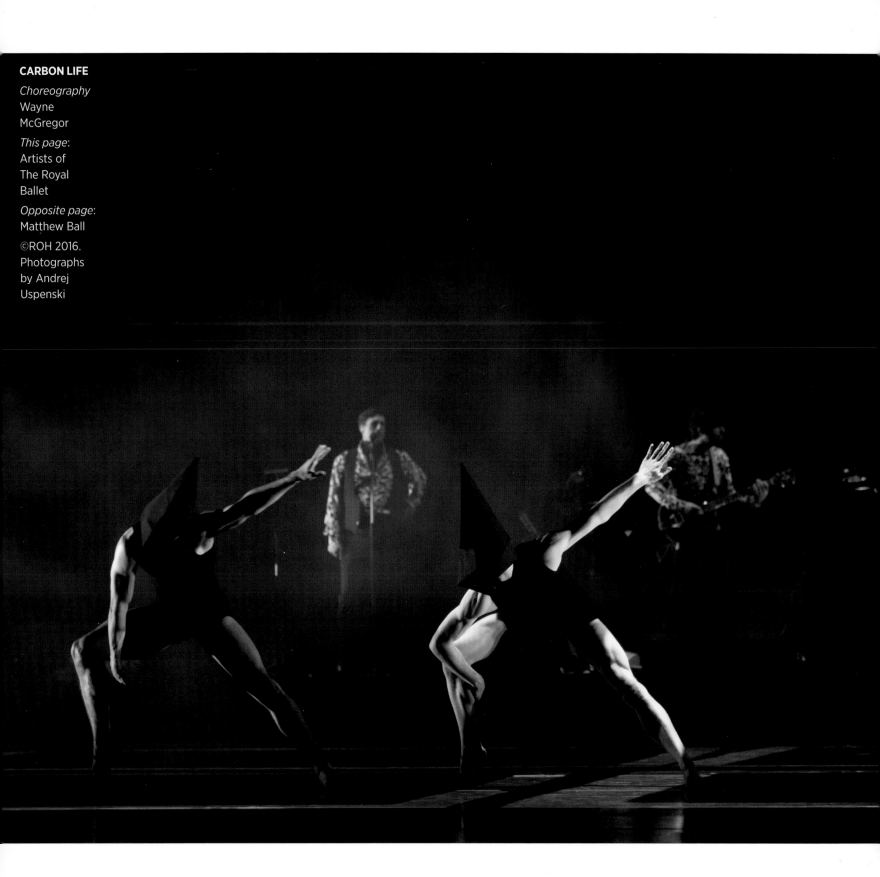

CARBON LIFE

Choreography
Wayne
McGregor

This page:
Artists of
The Royal
Ballet

Opposite page:
Matthew Ball

©ROH 2016.
Photographs
by Andrej
Uspenski

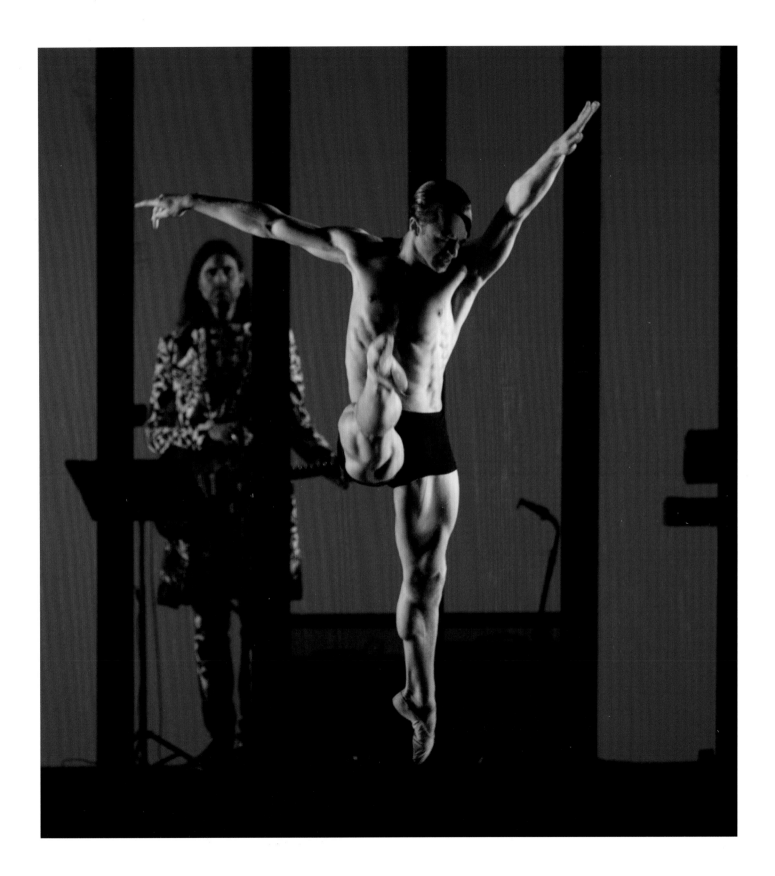

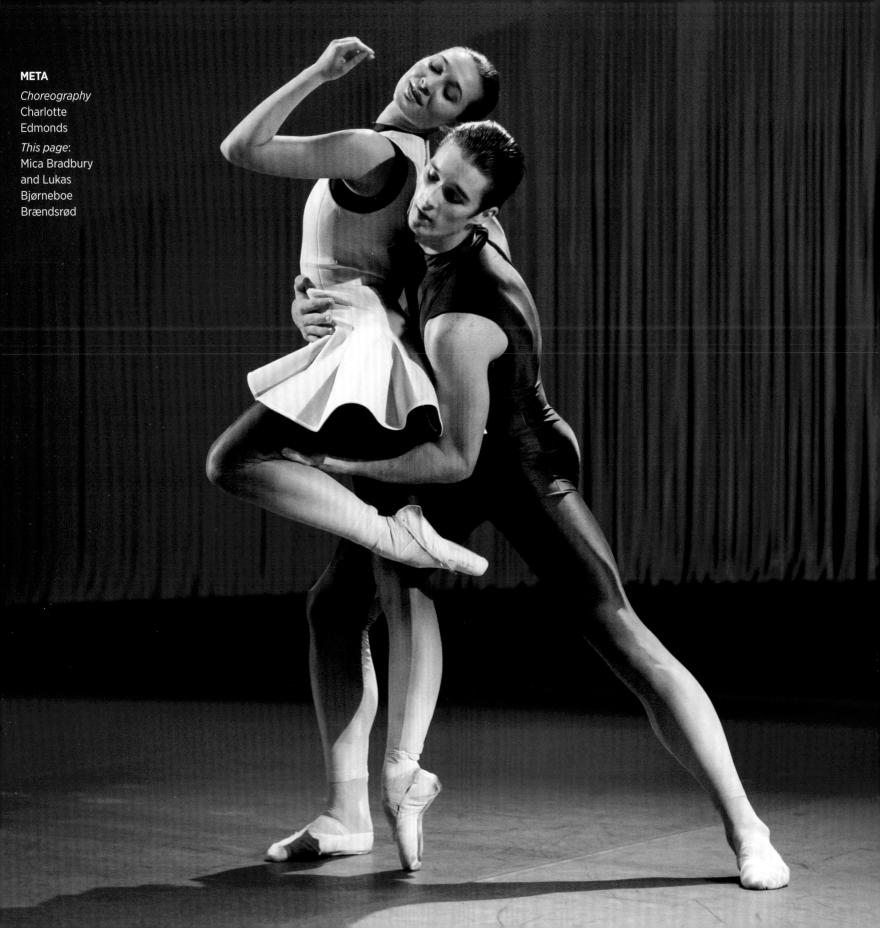

META

Choreography
Charlotte
Edmonds

This page:
Mica Bradbury
and Lukas
Bjørneboe
Brændsrød

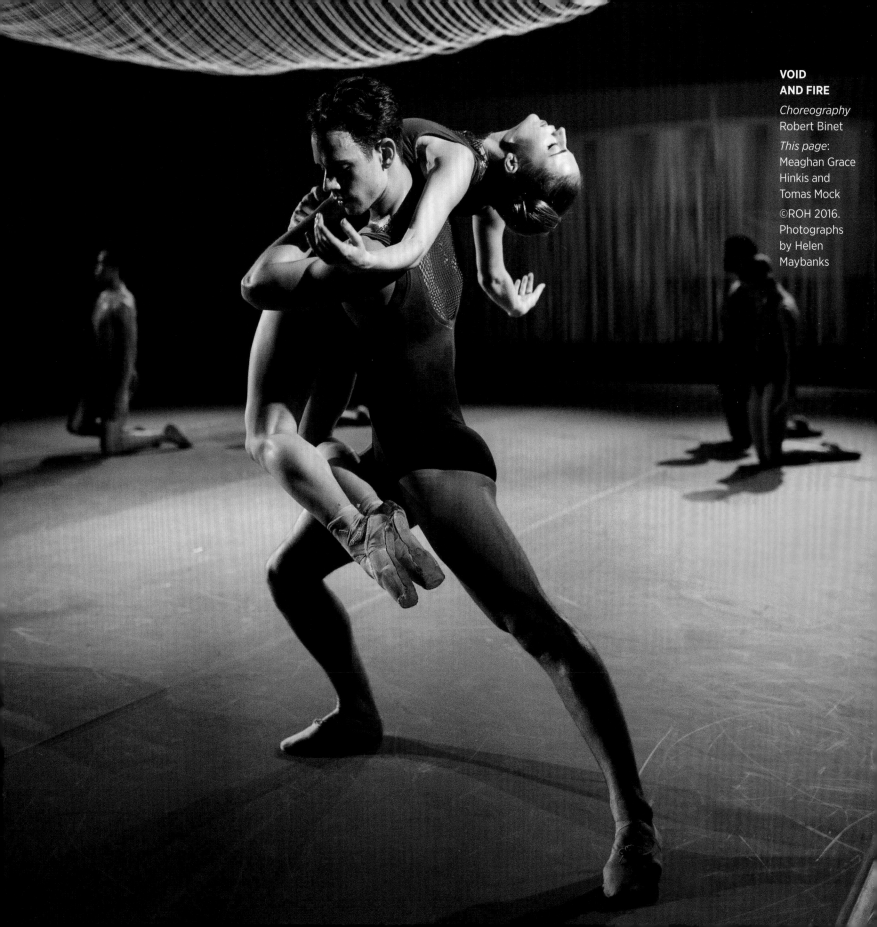

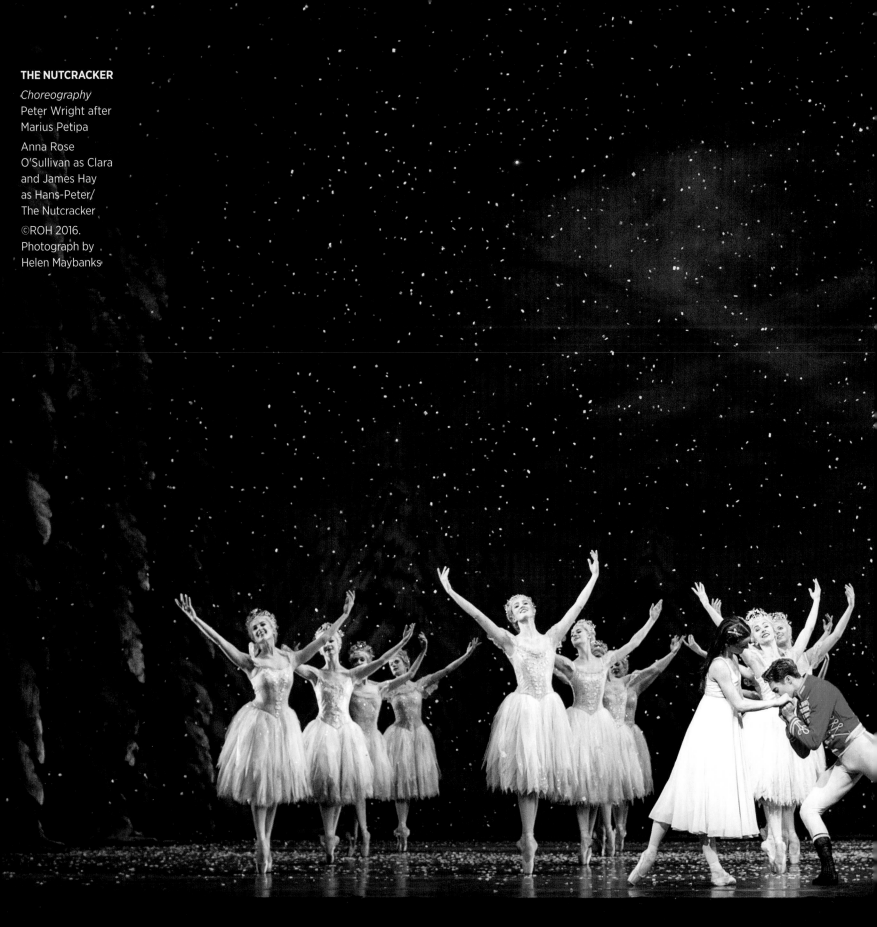

THE NUTCRACKER

Choreography
Peter Wright after
Marius Petipa

Anna Rose
O'Sullivan as Clara
and James Hay
as Hans-Peter/
The Nutcracker

©ROH 2016.
Photograph by
Helen Maybanks

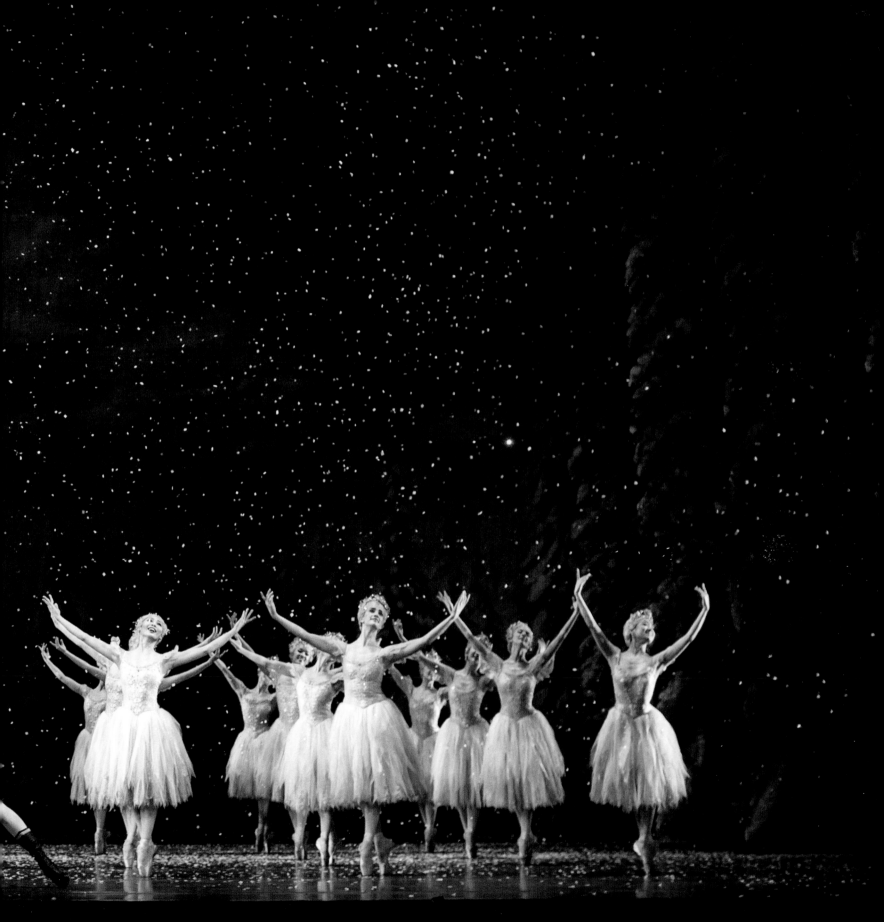

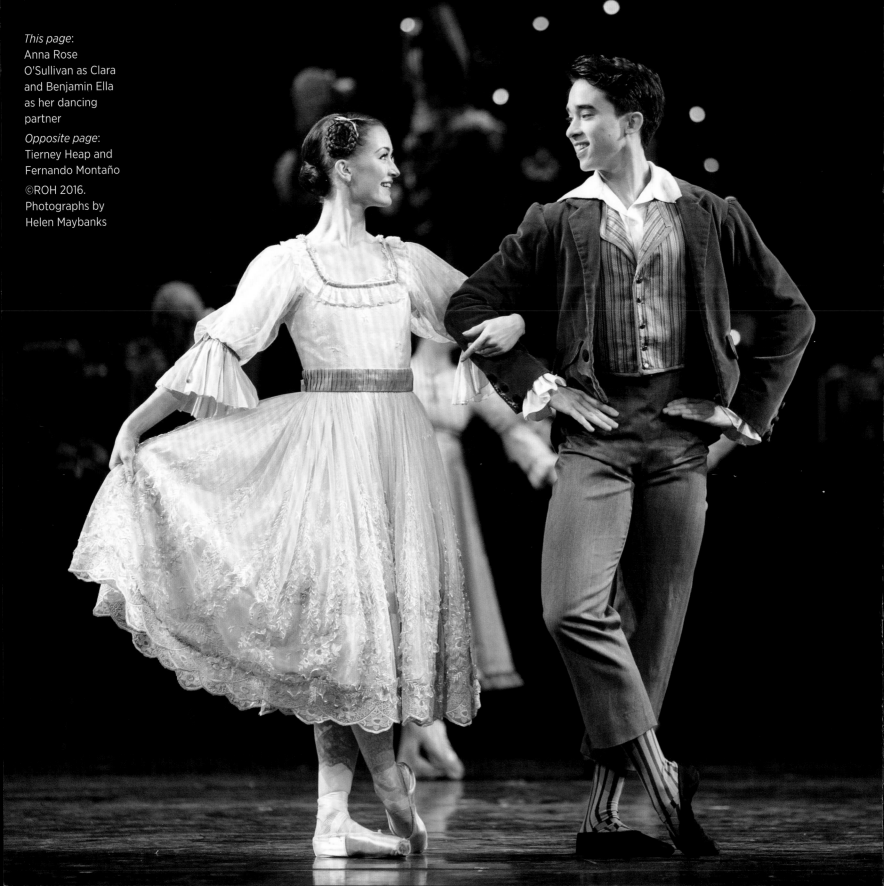

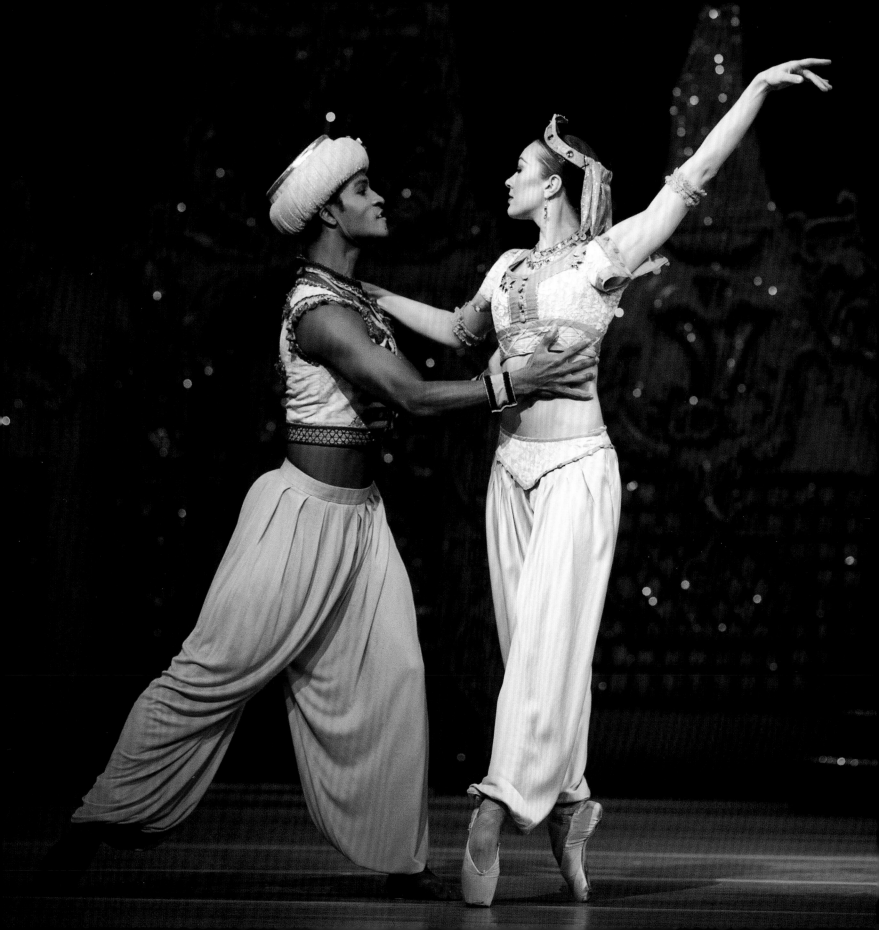

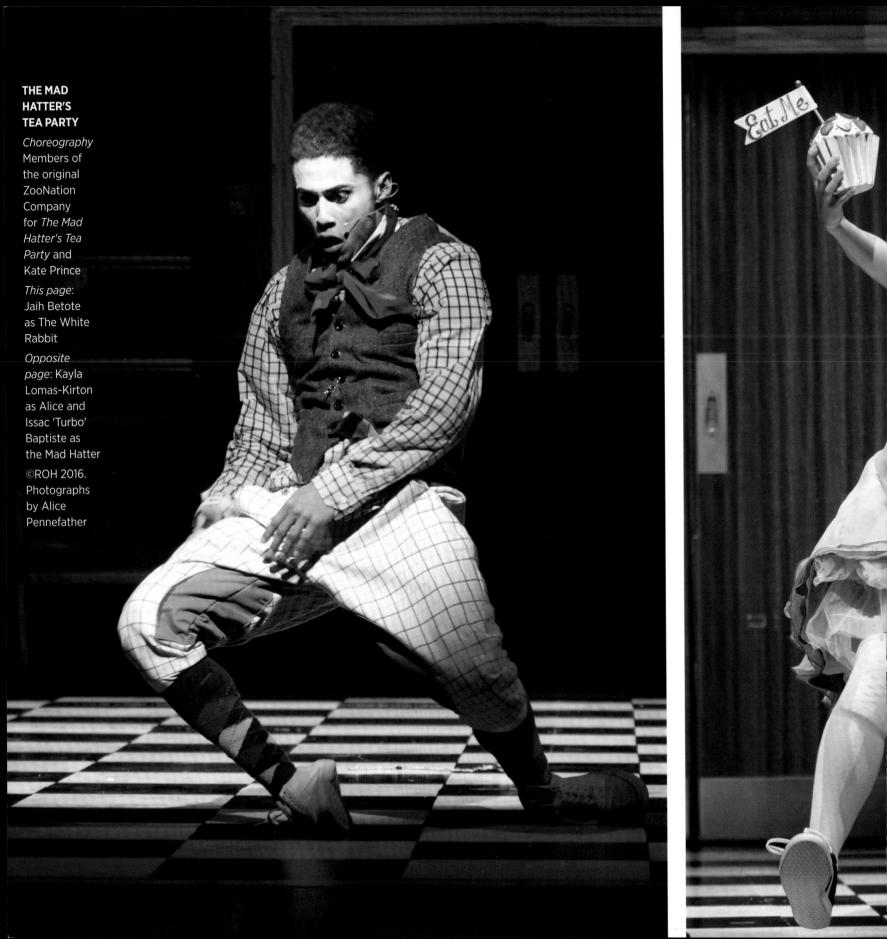

THE MAD HATTER'S TEA PARTY

Choreography Members of the original ZooNation Company for *The Mad Hatter's Tea Party* and Kate Prince

This page: Jaih Betote as The White Rabbit

Opposite page: Kayla Lomas-Kirton as Alice and Issac 'Turbo' Baptiste as the Mad Hatter ©ROH 2016. Photographs by Alice Pennefather

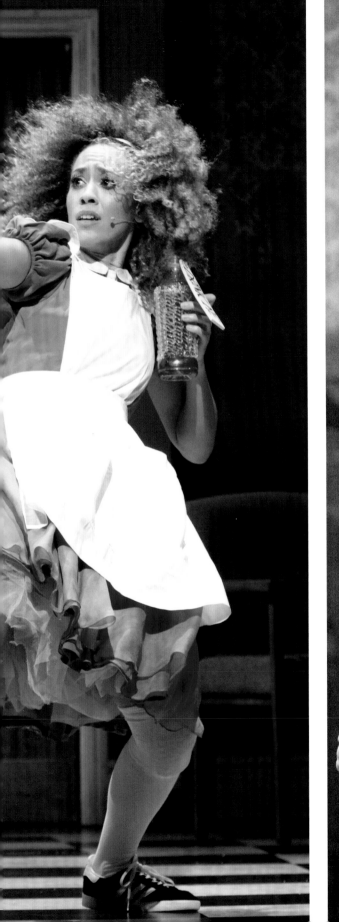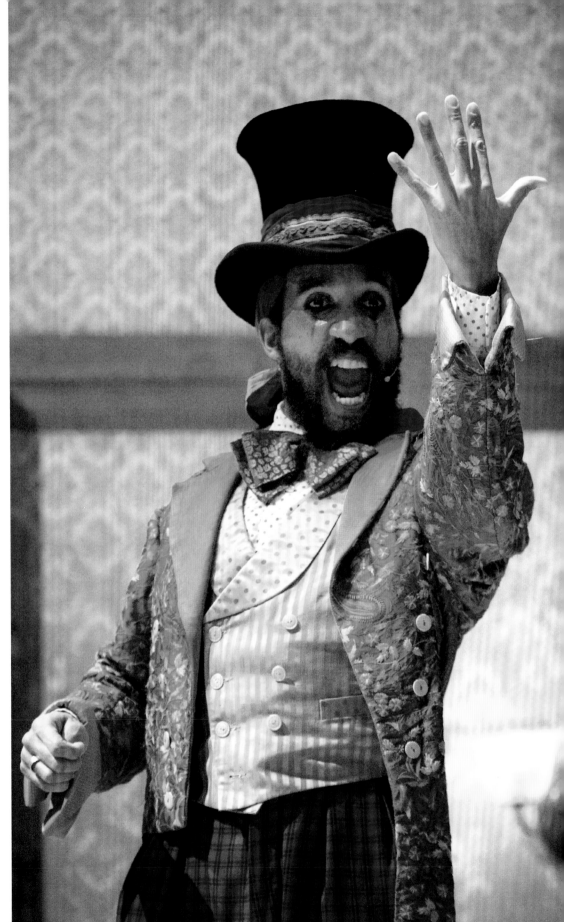

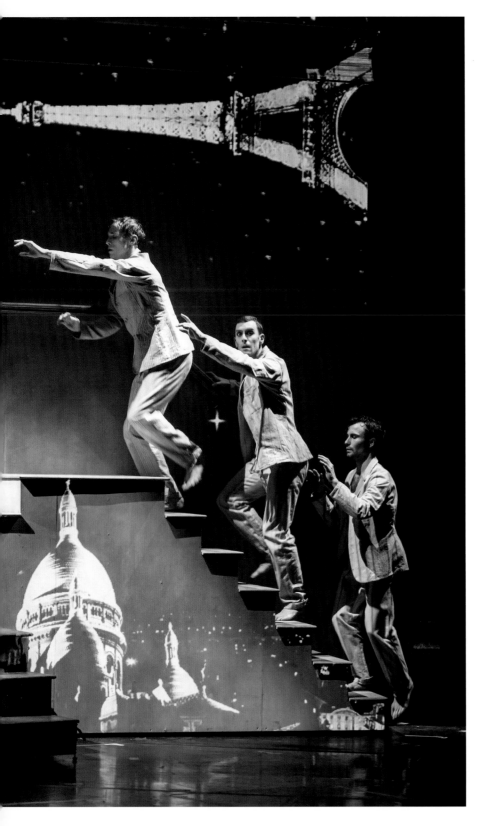

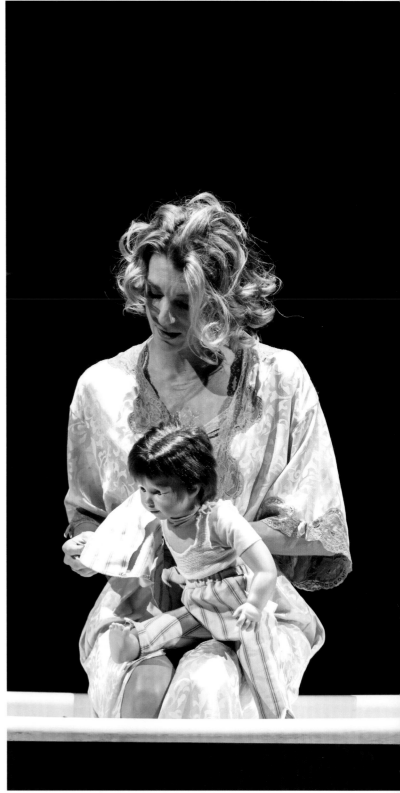

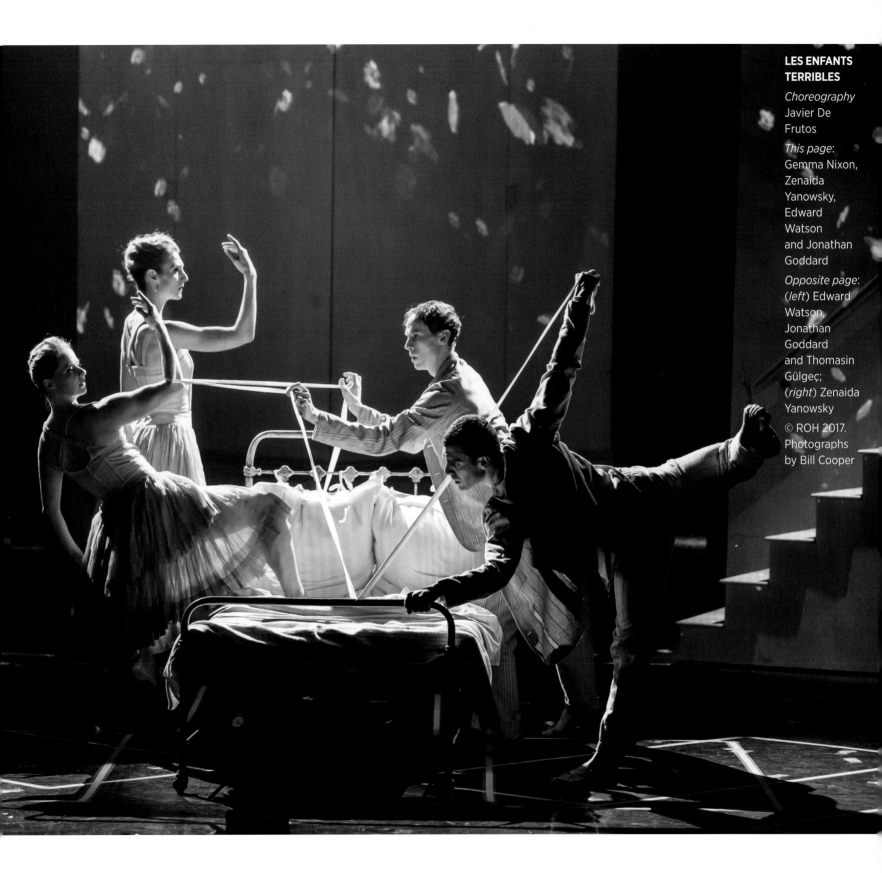

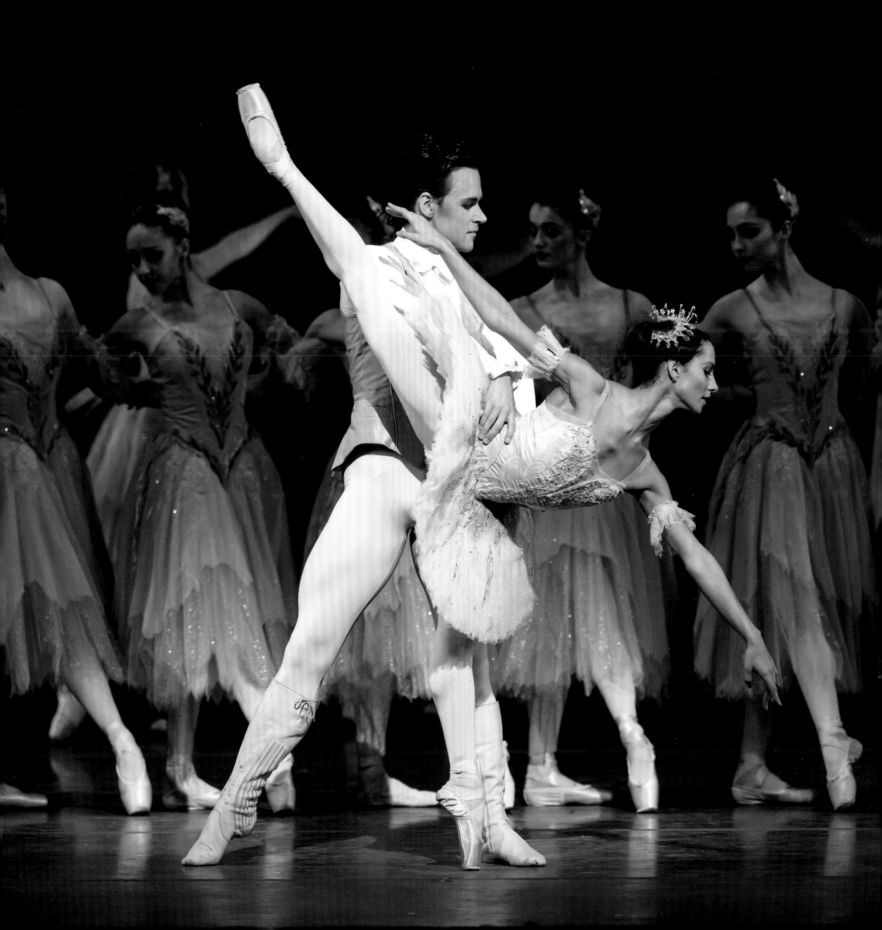

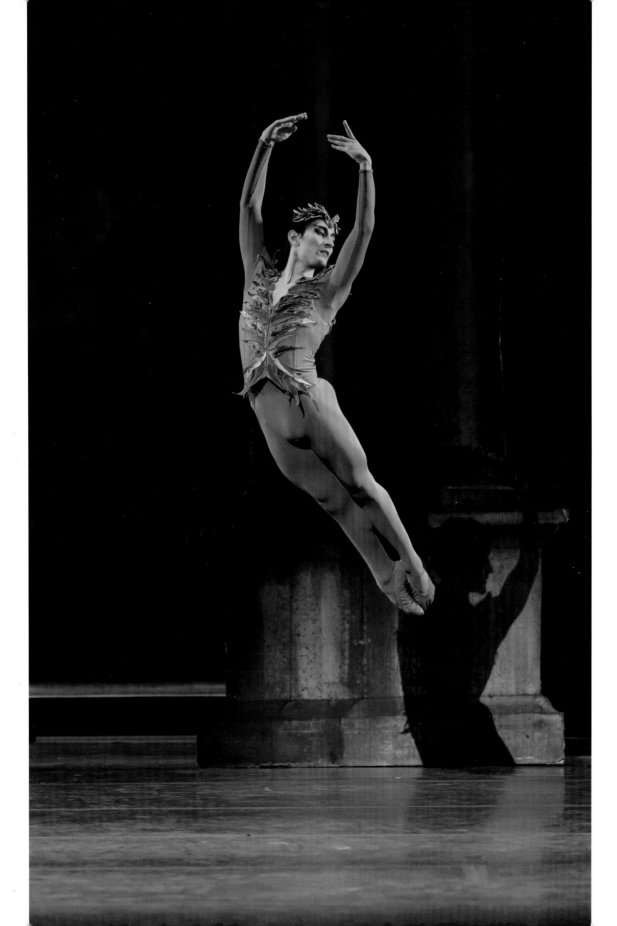

THE SLEEPING BEAUTY

Choreography
Marius Petipa

Production
Monica Mason
and Christopher
Newton after
Ninette de Valois
and Nicholas
Sergeyev

*Additional
Choreography*
Frederick Ashton,
Anthony Dowell
and Christopher
Wheeldon

This page:
Valentino
Zucchetti as
the Bluebird

Opposite page:
Francesca
Hayward as
Princess Aurora
and Alexander
Campbell as
Prince Florimund

©ROH 2017.
Photographs
by Bill Cooper

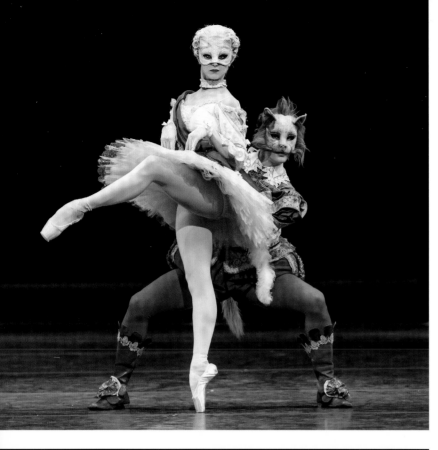
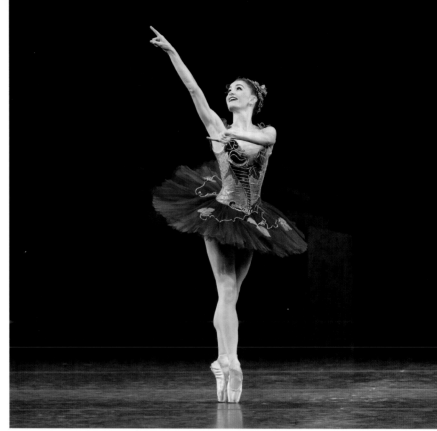
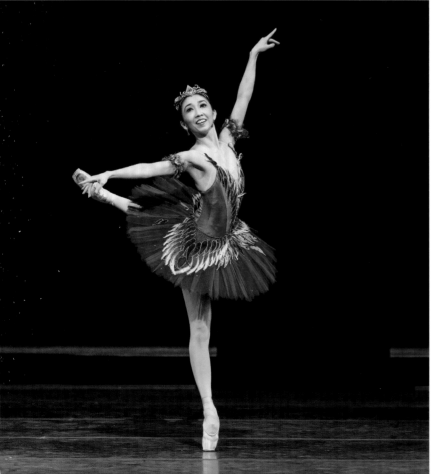
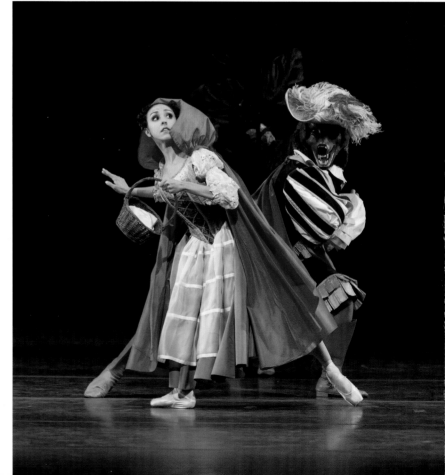

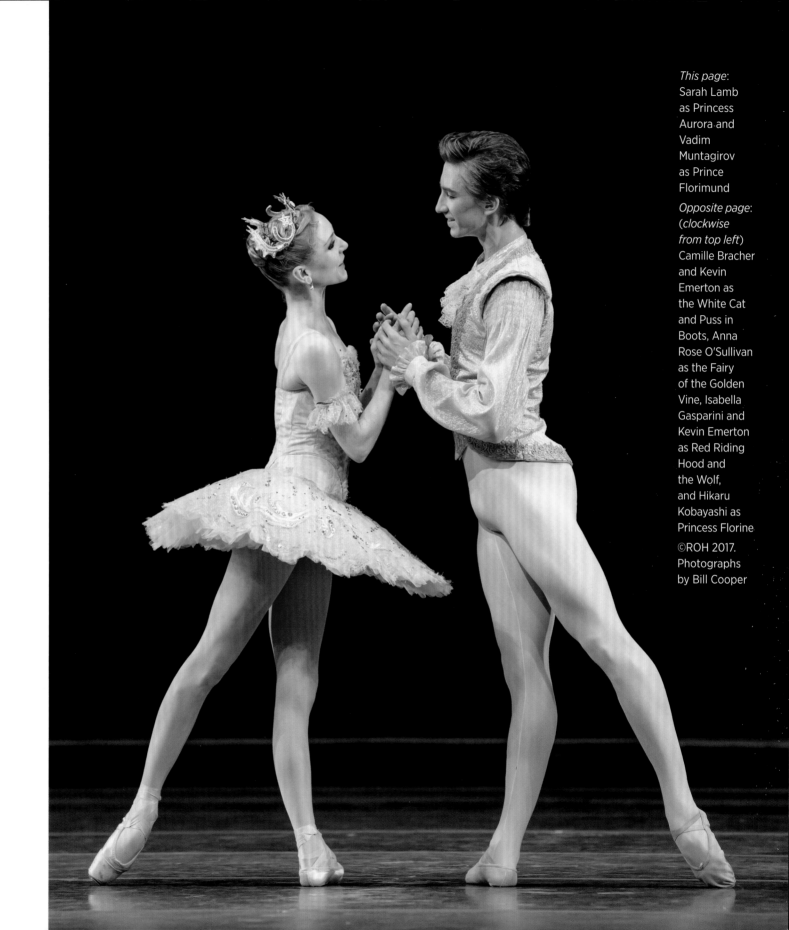

WOOLF
WORKS

Choreography
Wayne McGregor

This page: (*top*)
Matthew Ball
and Yuhui Choe;
(*bottom*) Akane
Takada; (*centre*)
Alessandra Ferri
and Beatriz
Stix-Brunell

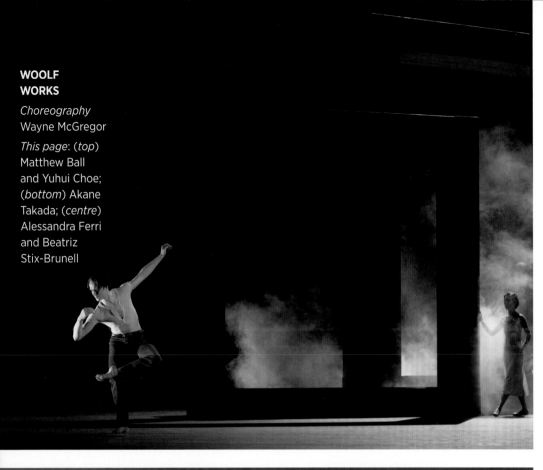

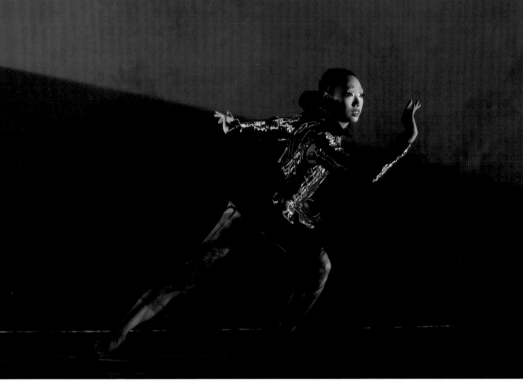

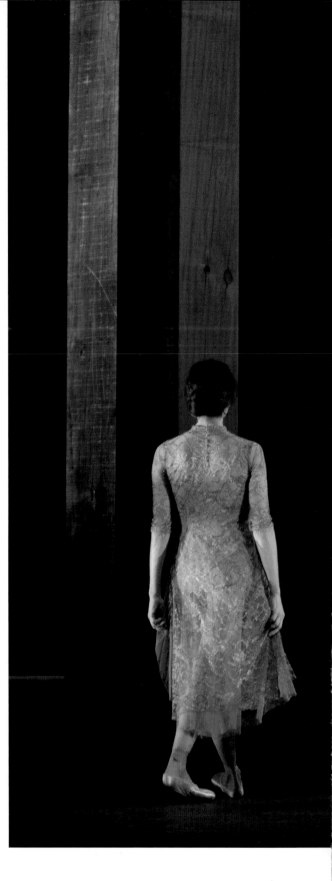

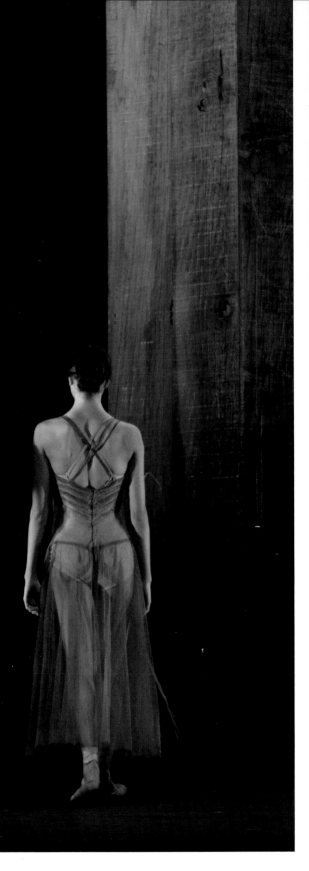

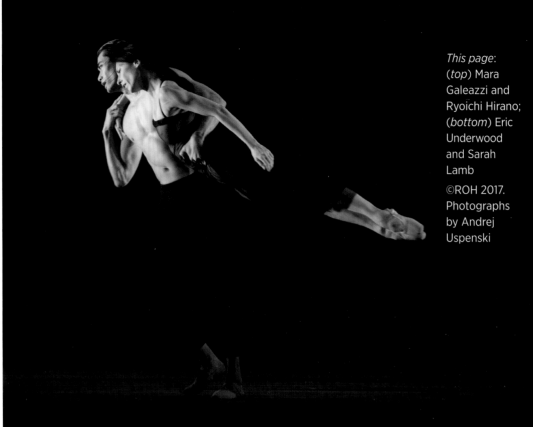

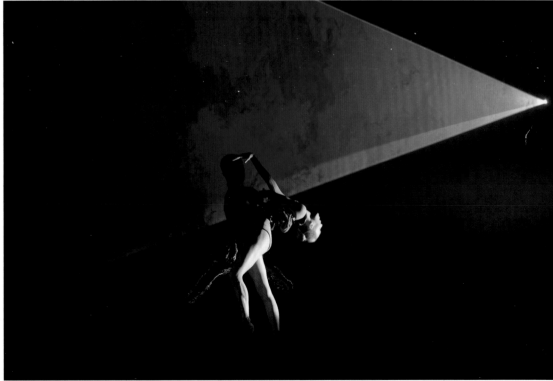

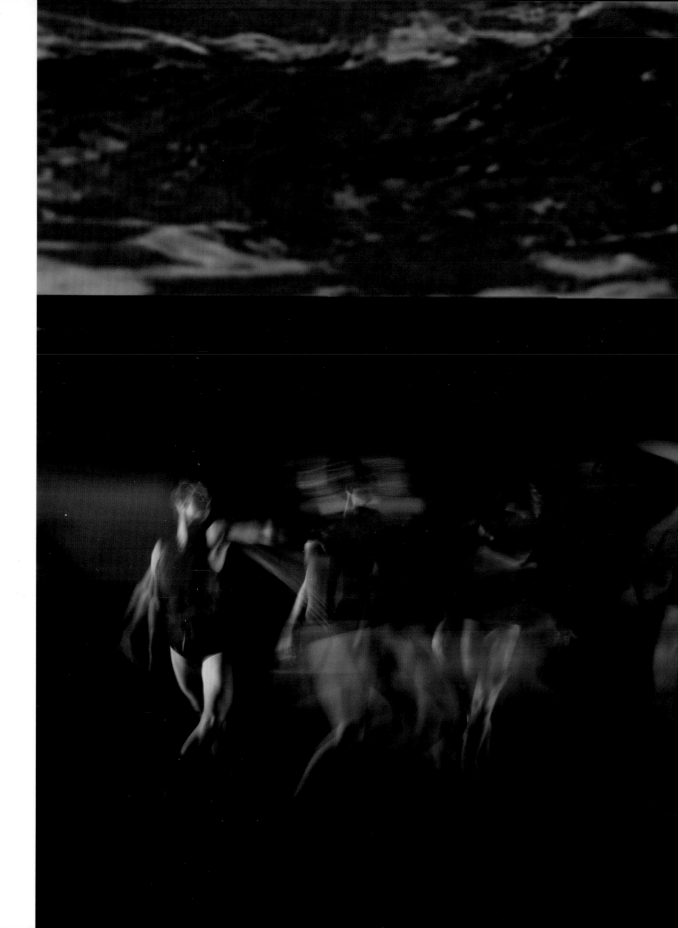

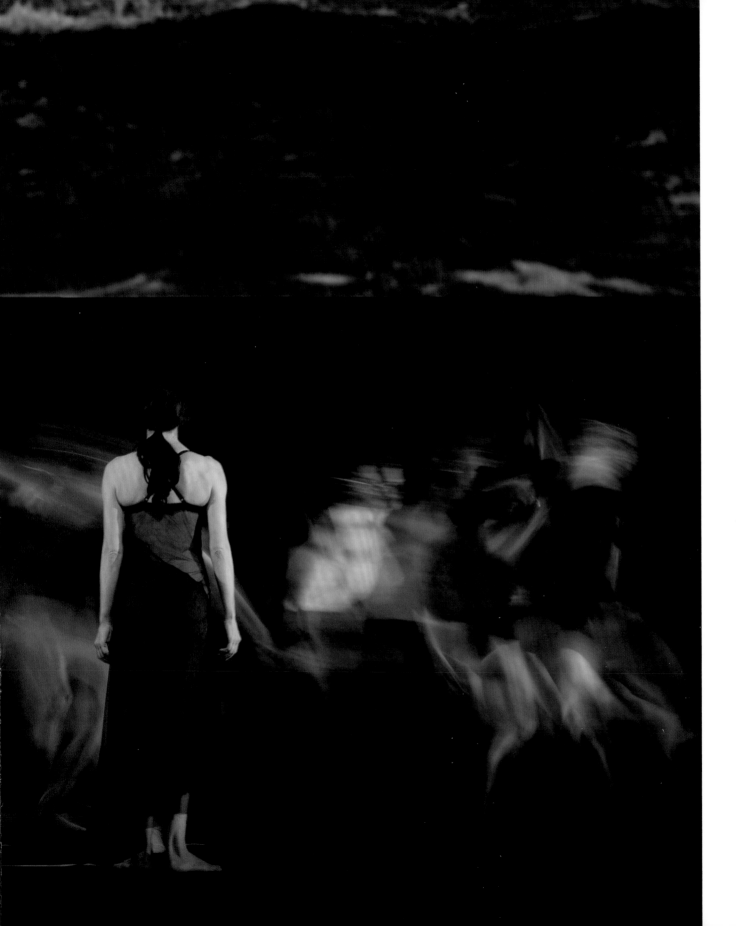

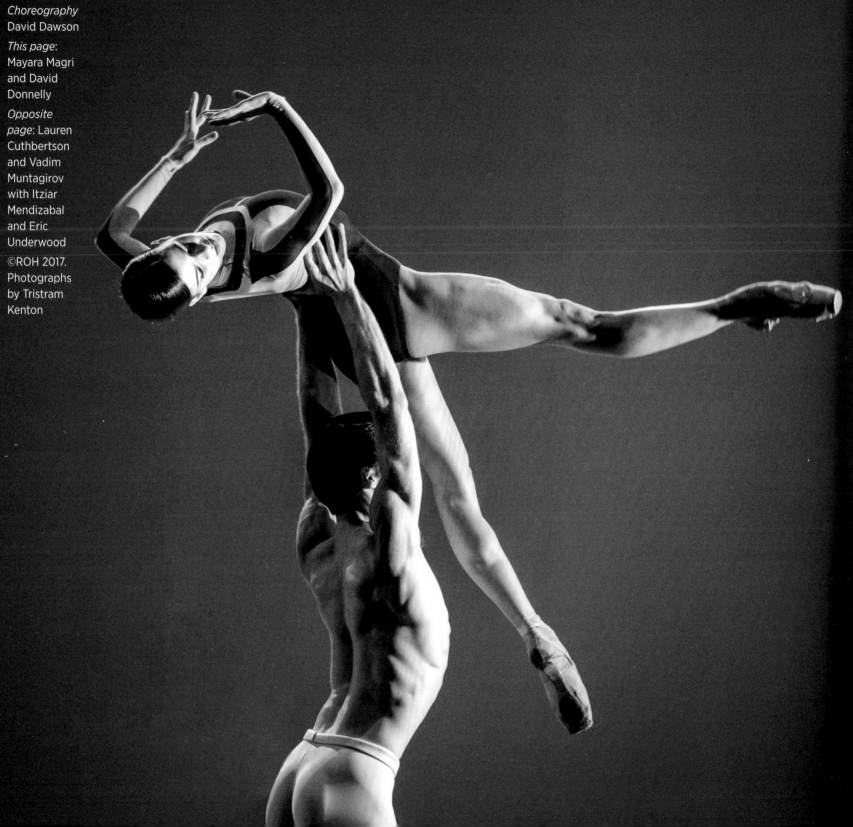

THE HUMAN SEASONS

Choreography
David Dawson

This page:
Mayara Magri
and David
Donnelly

Opposite page: Lauren
Cuthbertson
and Vadim
Muntagirov
with Itziar
Mendizabal
and Eric
Underwood

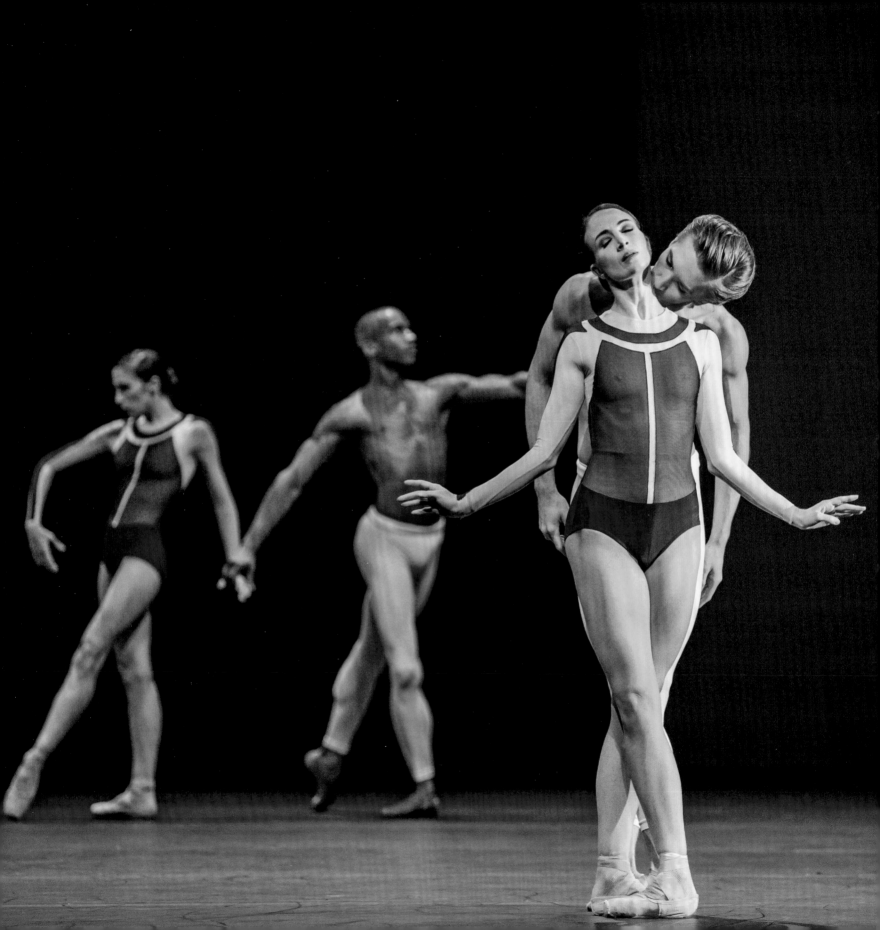

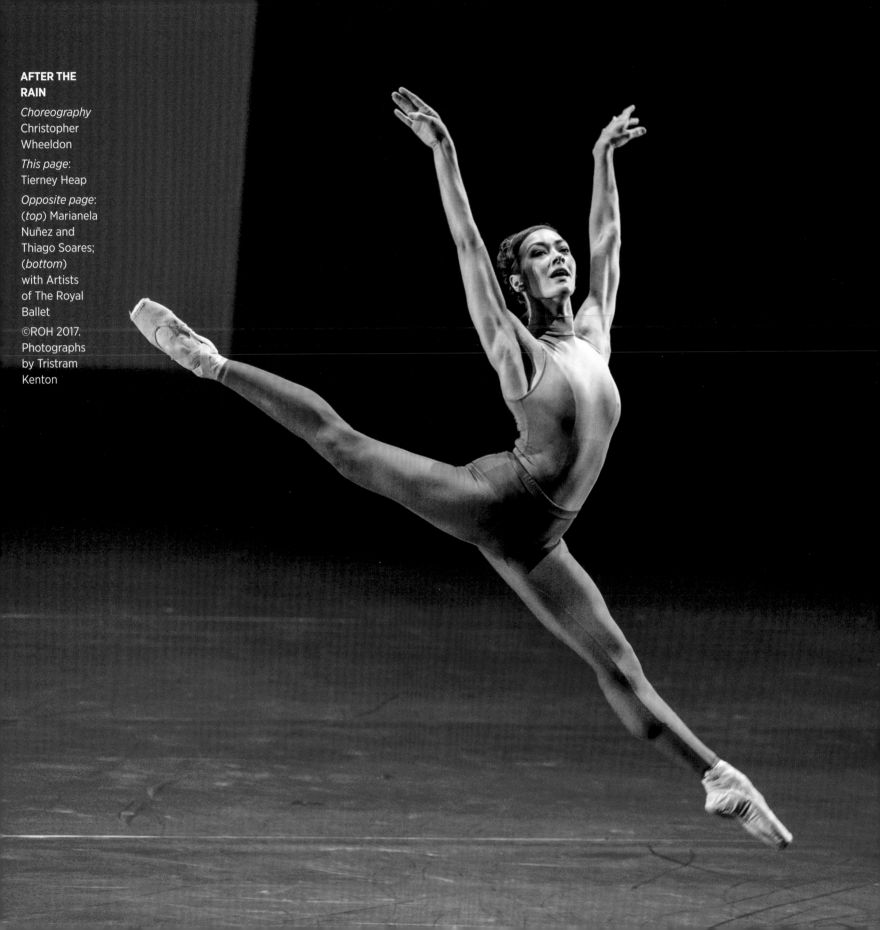

AFTER THE RAIN

Choreography
Christopher
Wheeldon

This page:
Tierney Heap

Opposite page:
(*top*) Marianela
Nuñez and
Thiago Soares;
(*bottom*)
with Artists
of The Royal
Ballet

©ROH 2017.
Photographs
by Tristram
Kenton

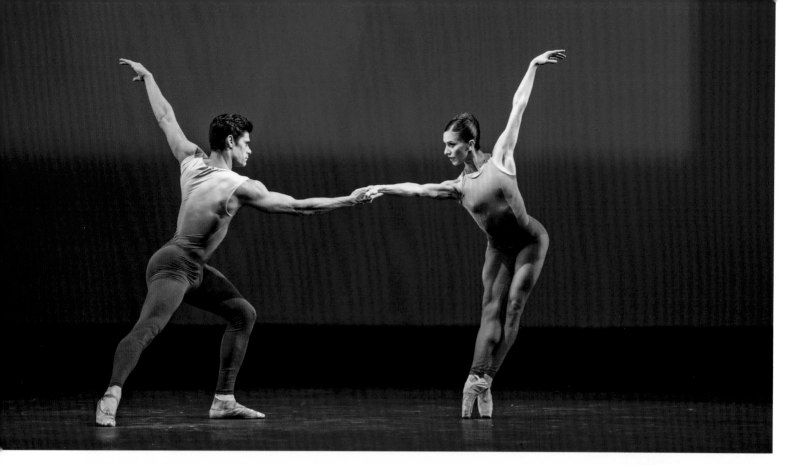

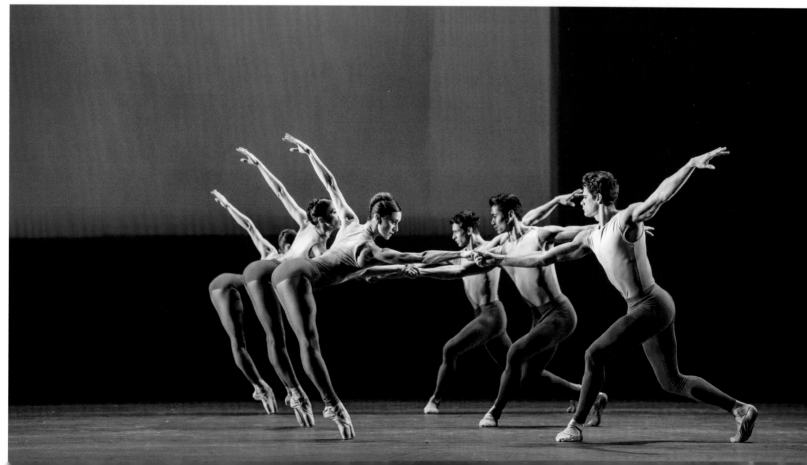

FLIGHT PATTERN

Choreography
Crystal Pite

(*left to right*)
Marcelino Sambé, Artists of The Royal Ballet, Kristen McNally and Artists of The Royal Ballet

Next page:
Artists of The Royal Ballet

©ROH 2017. Photographs by Tristram Kenton

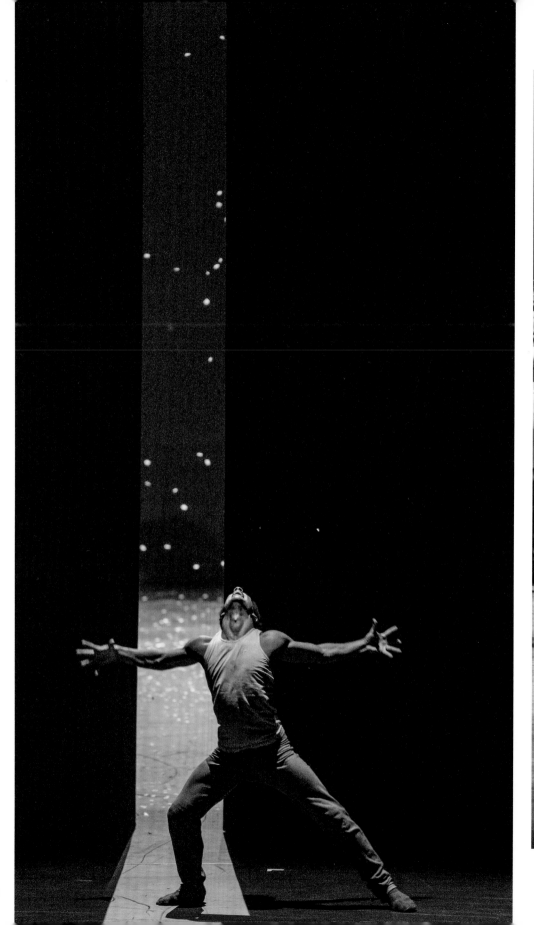
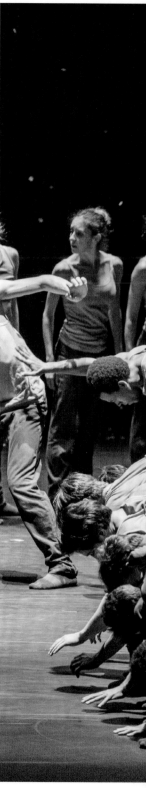

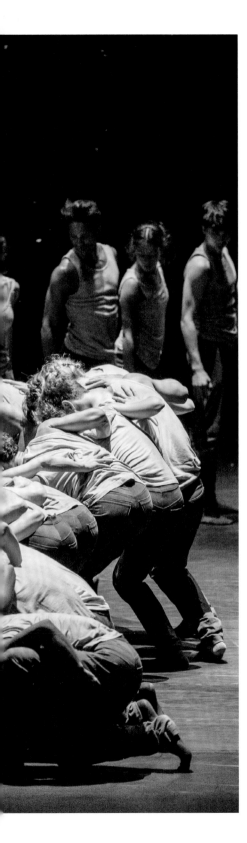
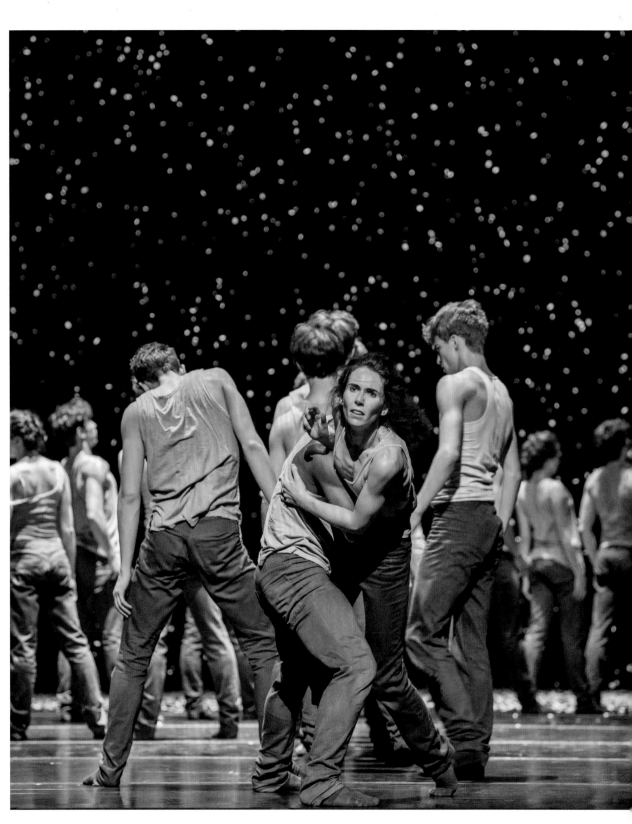

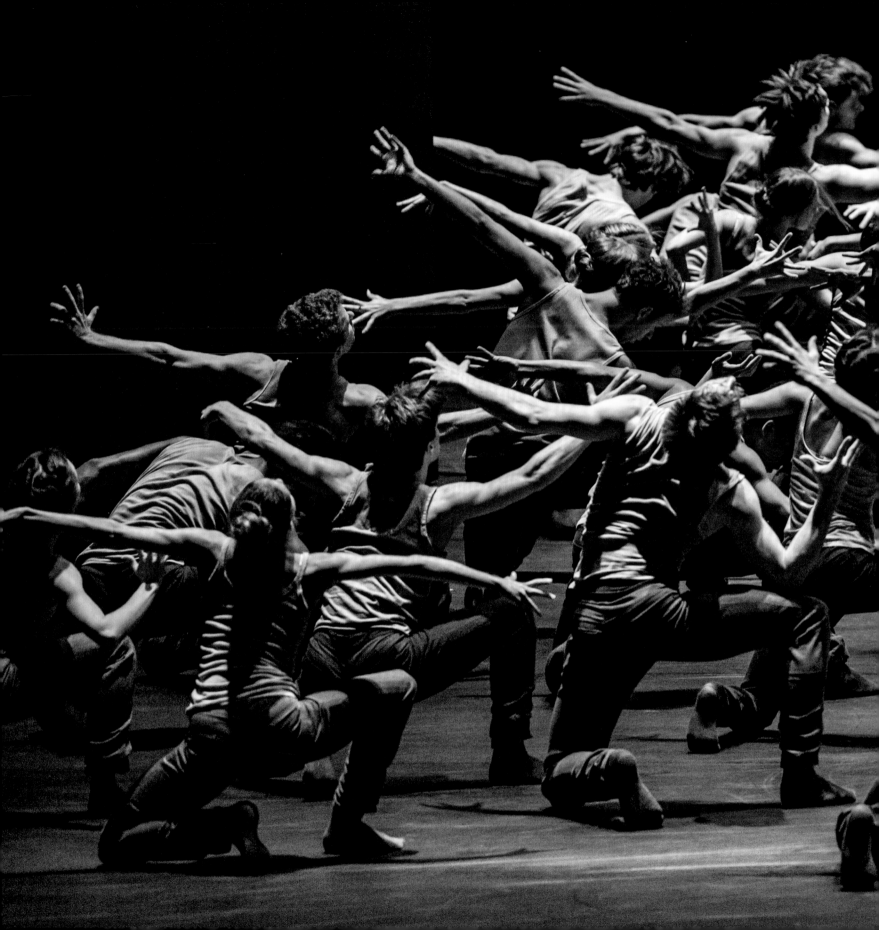

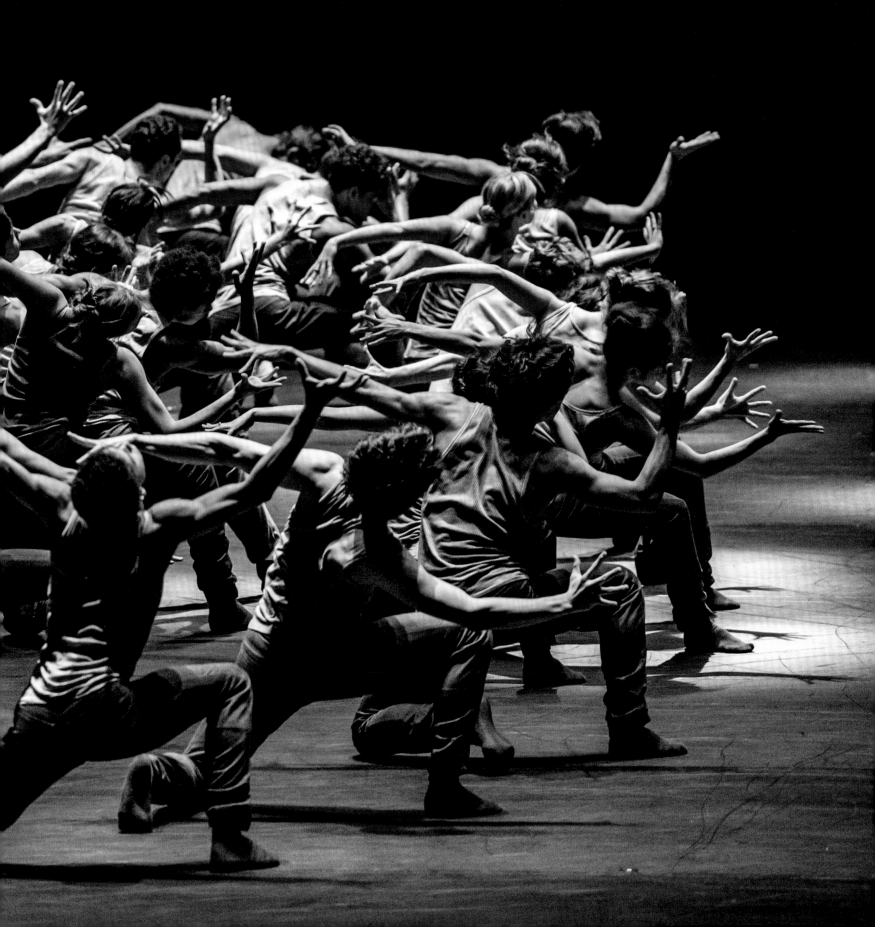

JEWELS

Choreography
George
Balanchine

This page:
(*top*) Sarah
Lamb and
Steven McRae
in 'Rubies';
(*bottom*)
Marianela
Nuñez and
Thiago Soares
in 'Diamonds'

Opposite page:
Helen
Crawford,
Beatriz
Stix-Brunell,
Valeri Hristov,
James Hay,
Ryoichi Hirano,
Anna Rose
O'Sullivan and
Laura Morera
in 'Emeralds'

© ROH 2017.
Photographs
by Alastair Muir

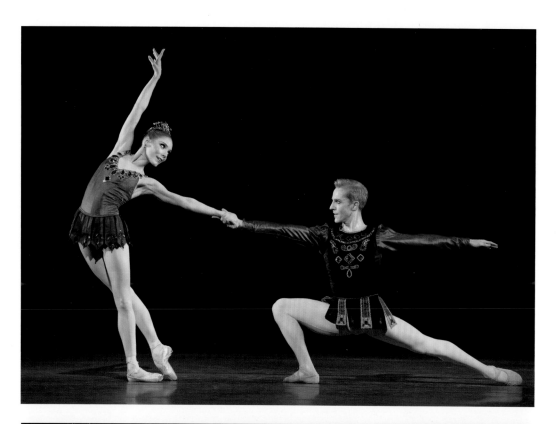

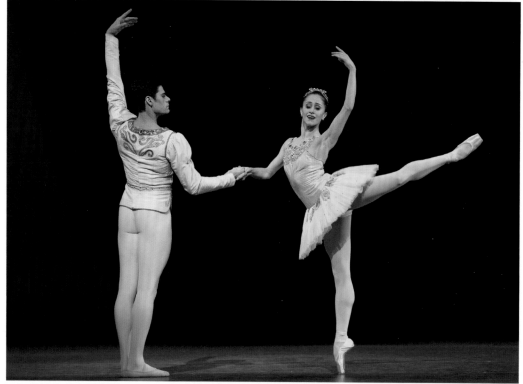

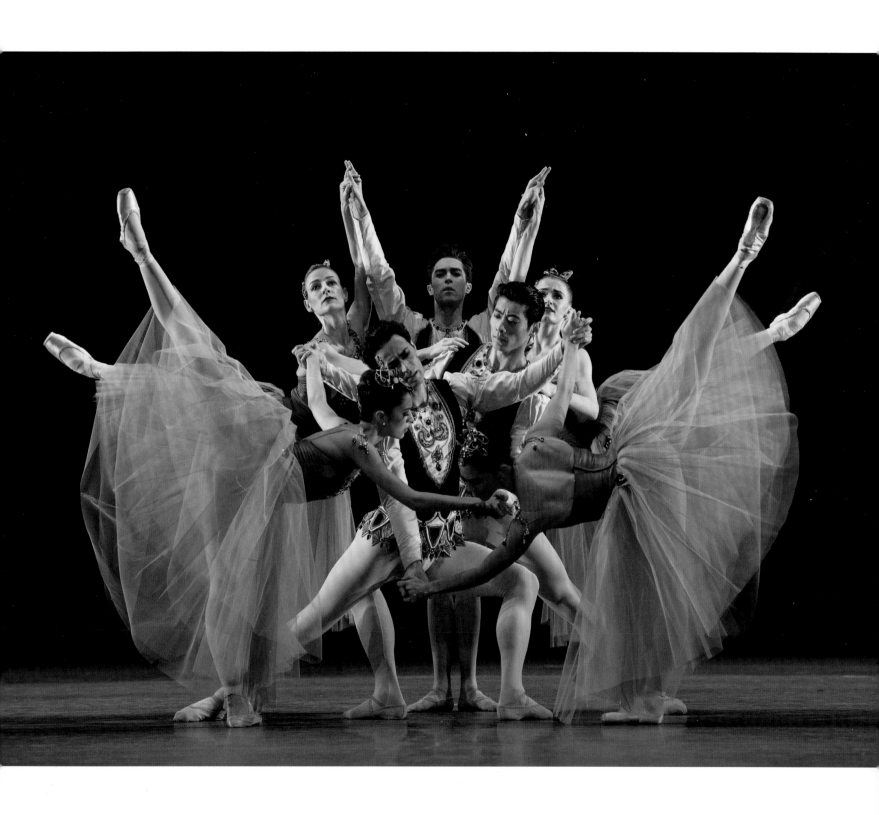

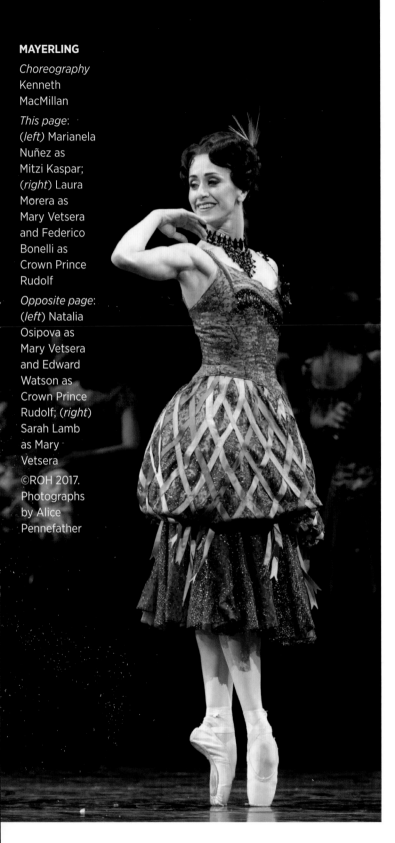

MAYERLING

Choreography
Kenneth
MacMillan

This page:
(*left*) Marianela
Nuñez as
Mitzi Kaspar;
(*right*) Laura
Morera as
Mary Vetsera
and Federico
Bonelli as
Crown Prince
Rudolf

Opposite page:
(*left*) Natalia
Osipova as
Mary Vetsera
and Edward
Watson as
Crown Prince
Rudolf; (*right*)
Sarah Lamb
as Mary
Vetsera

©ROH 2017.
Photographs
by Alice
Pennefather

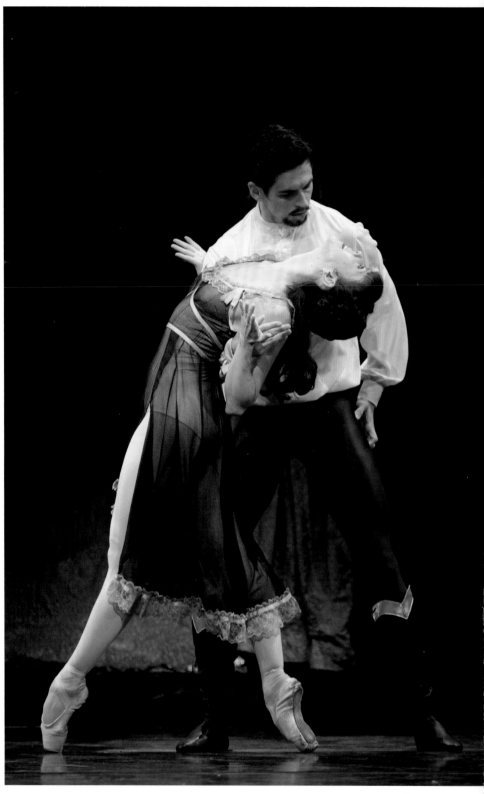

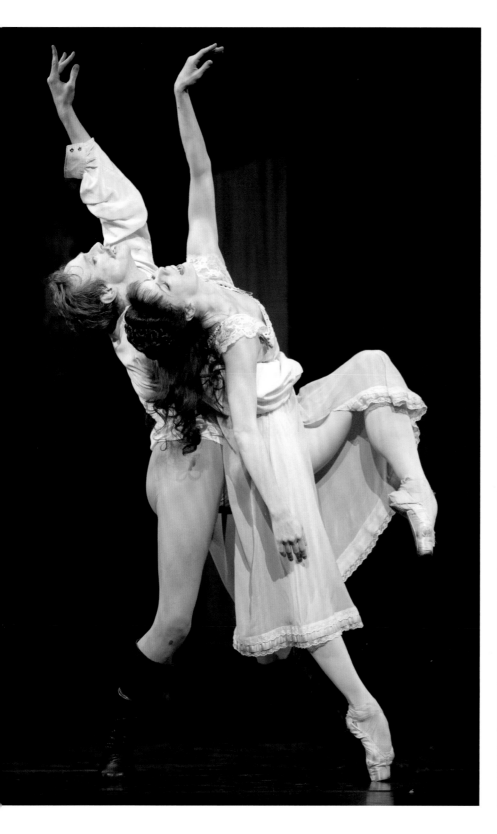
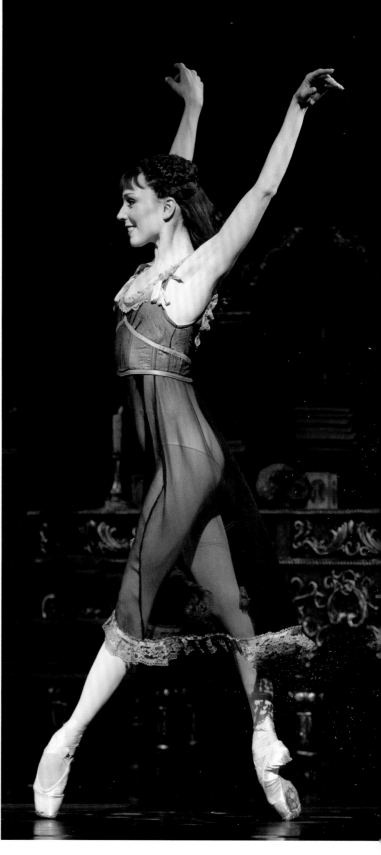

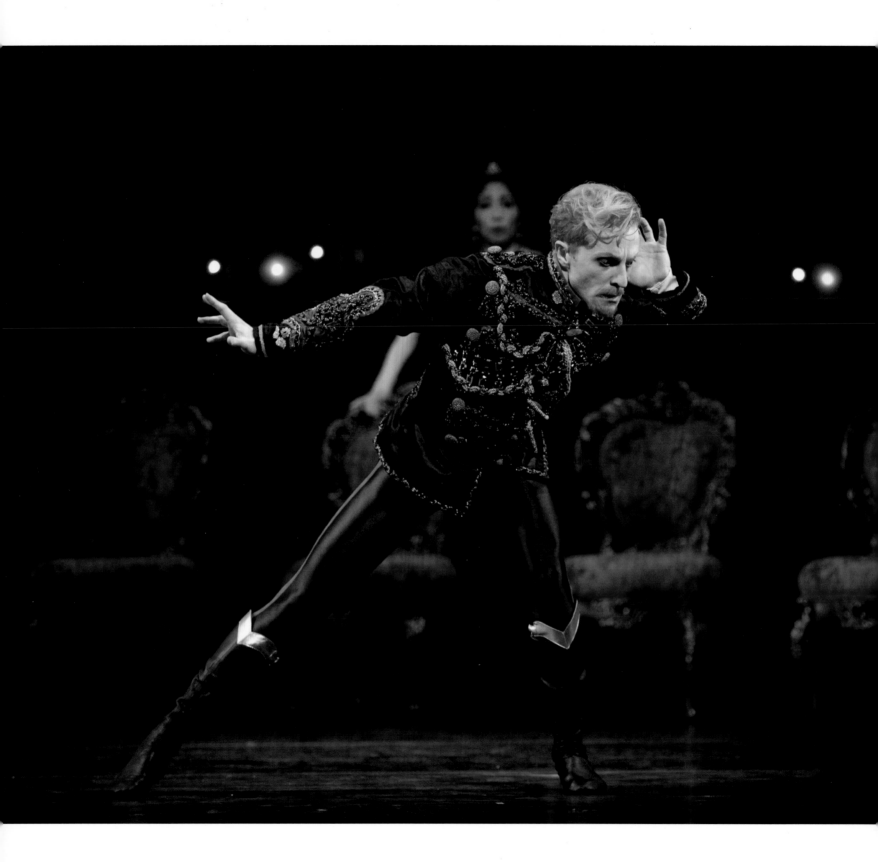

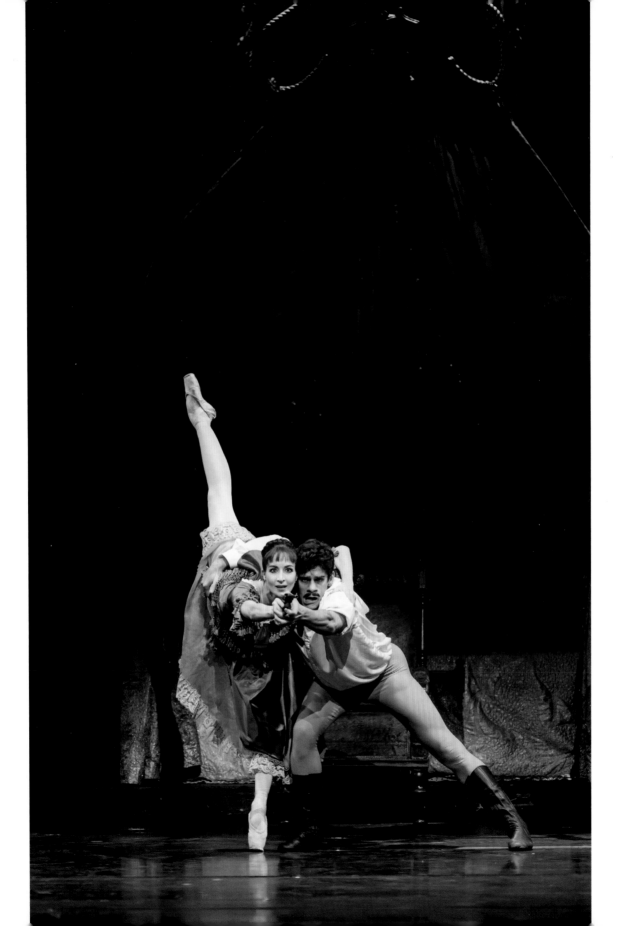

This page:
Lauren
Cuthbertson as
Mary Vetsera
and Thiago
Soares as
Crown Prince
Rudolf

©ROH 2017.
Photograph
by Bill Cooper

Opposite page:
Steven McRae
as Crown
Prince Rudolf

©ROH 2017.
Photograph
by Alice
Pennefather

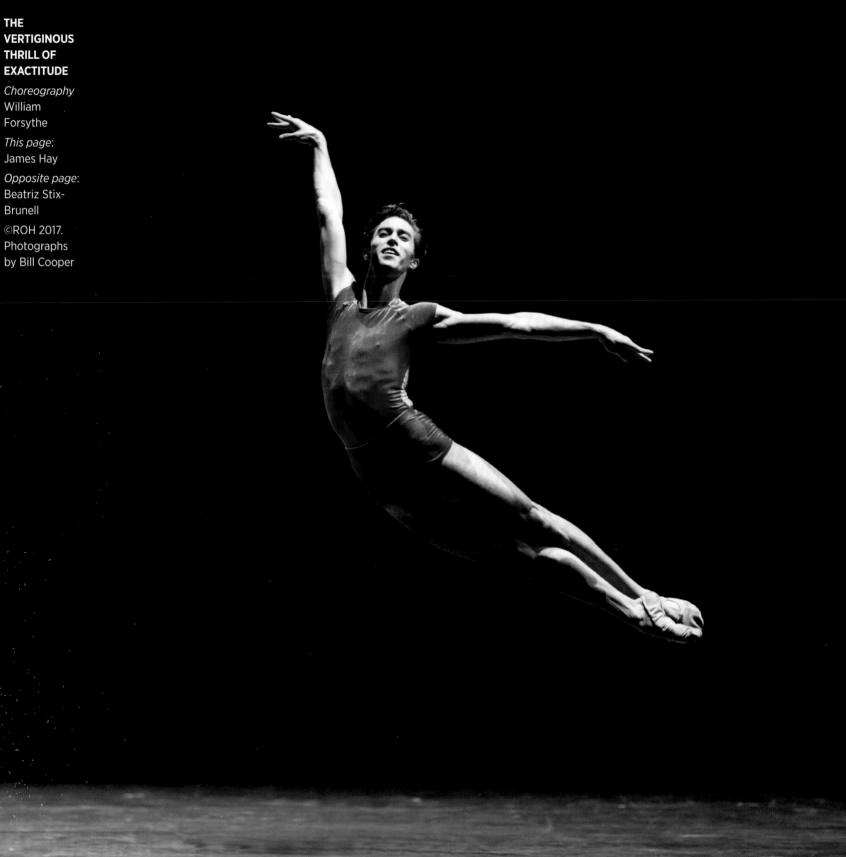

THE VERTIGINOUS THRILL OF EXACTITUDE

Choreography
William Forsythe

This page:
James Hay

Opposite page:
Beatriz Stix-Brunell

©ROH 2017.
Photographs
by Bill Cooper

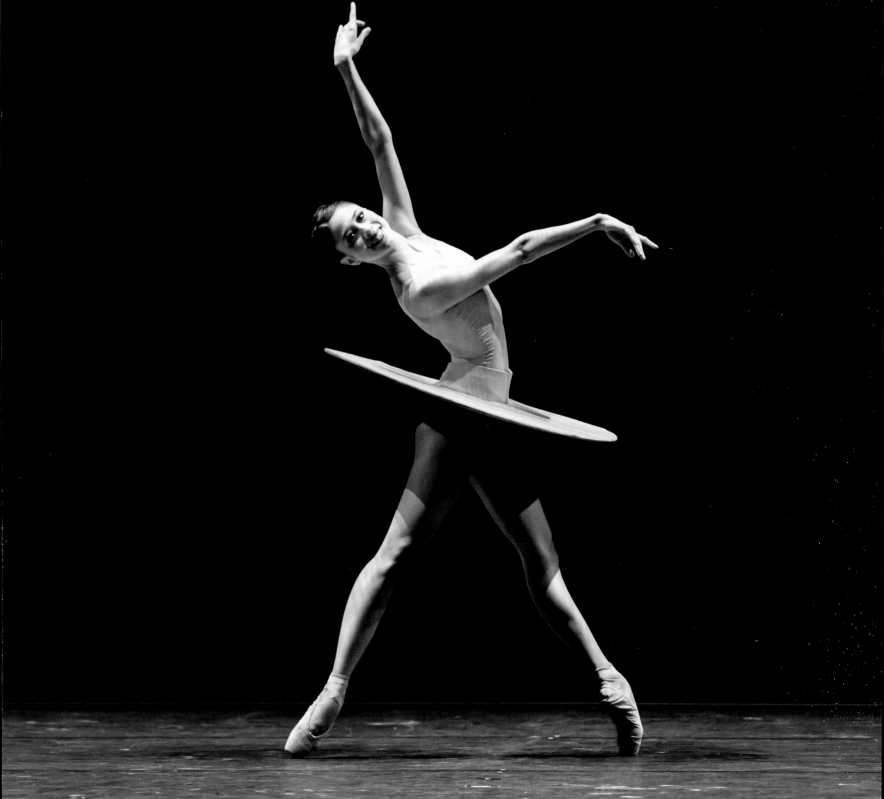

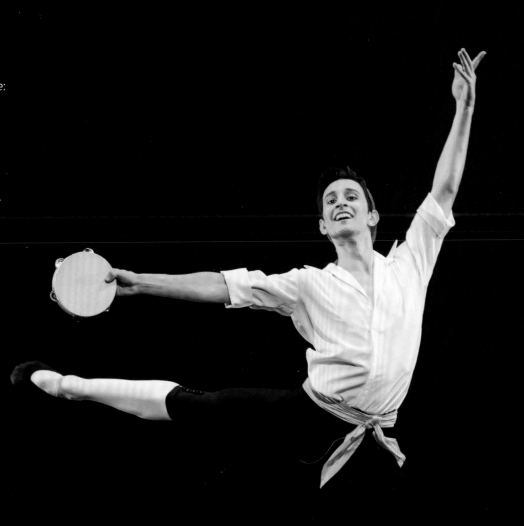

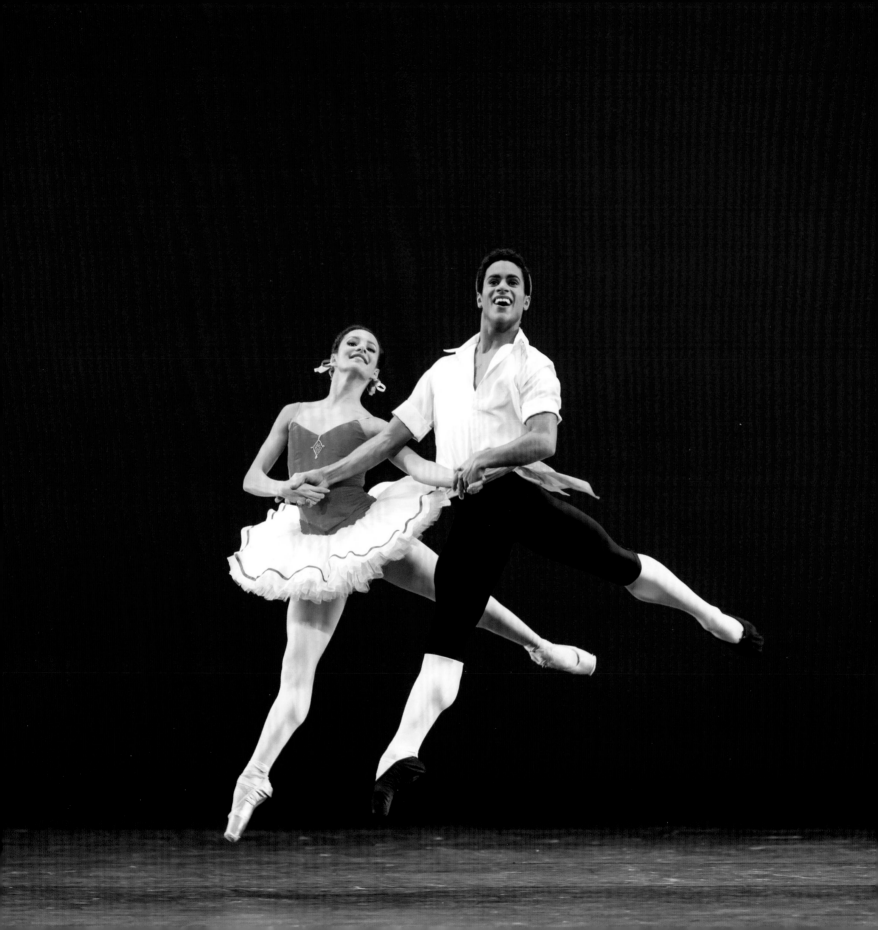

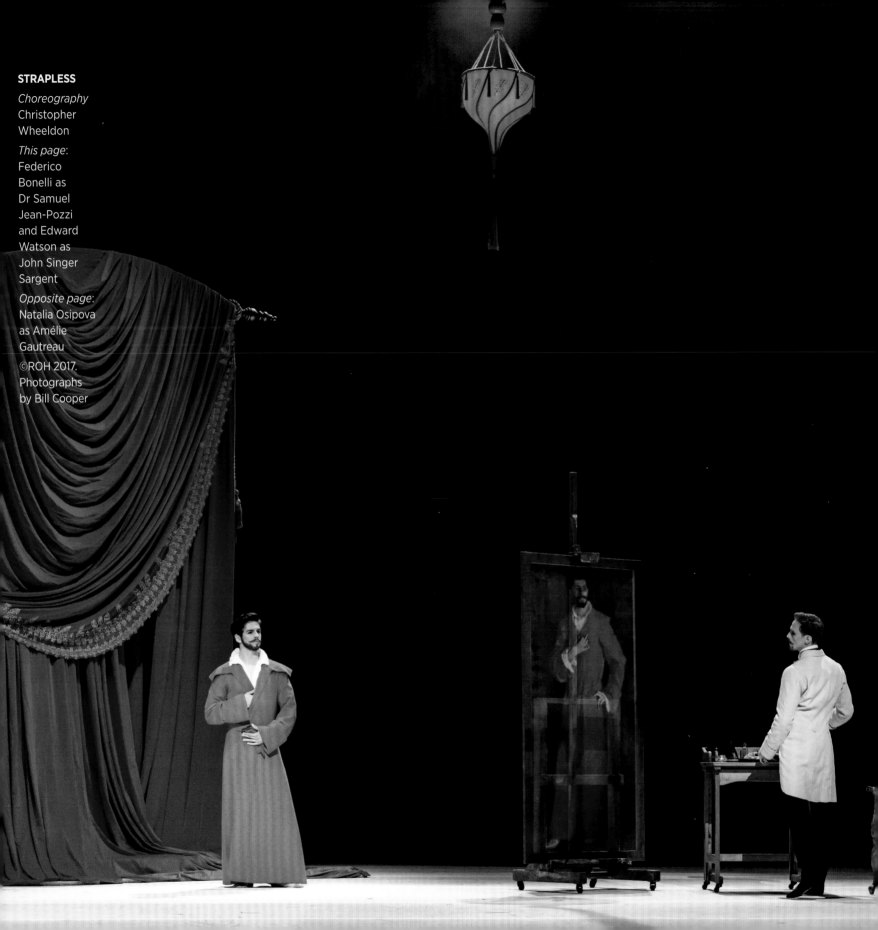

STRAPLESS

Choreography
Christopher
Wheeldon

This page:
Federico
Bonelli as
Dr Samuel
Jean-Pozzi
and Edward
Watson as
John Singer
Sargent

Opposite page:
Natalia Osipova
as Amélie
Gautreau

©ROH 2017.
Photographs
by Bill Cooper

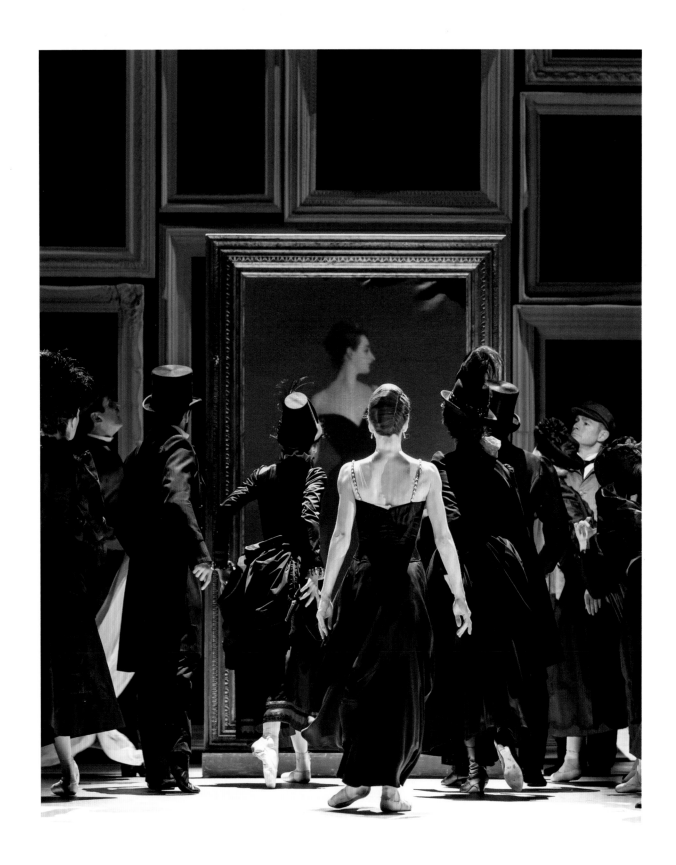

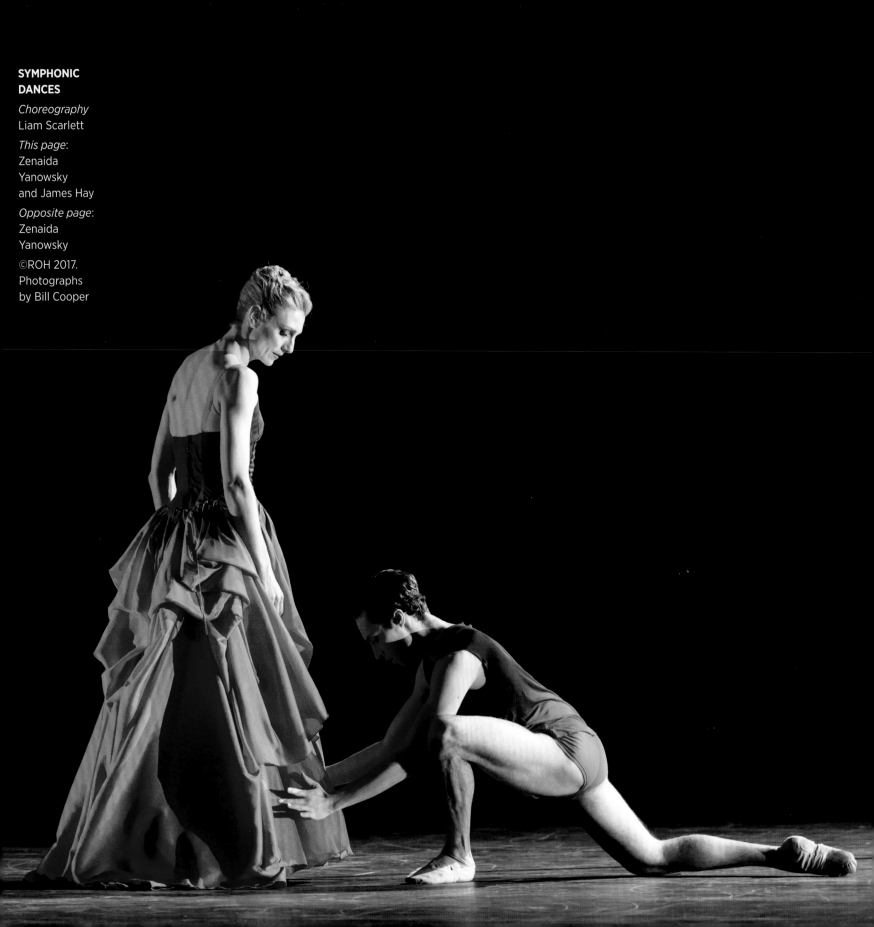

SYMPHONIC DANCES

Choreography
Liam Scarlett

This page:
Zenaida
Yanowsky
and James Hay

Opposite page:
Zenaida
Yanowsky

©ROH 2017.
Photographs
by Bill Cooper

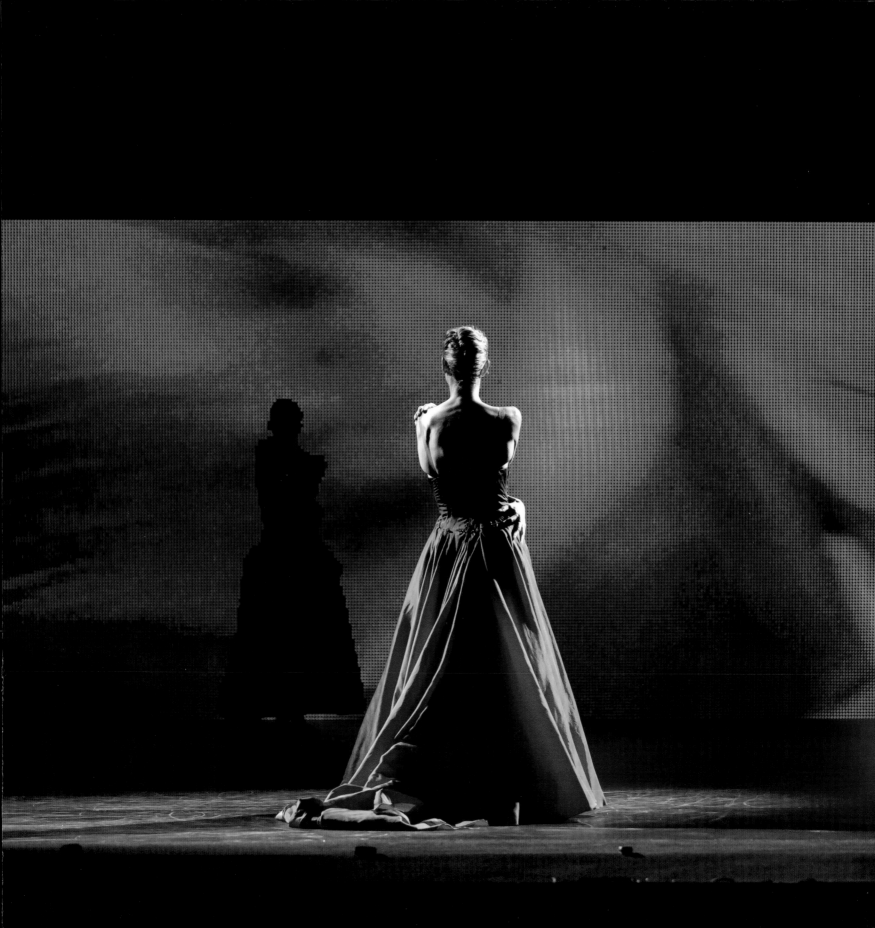

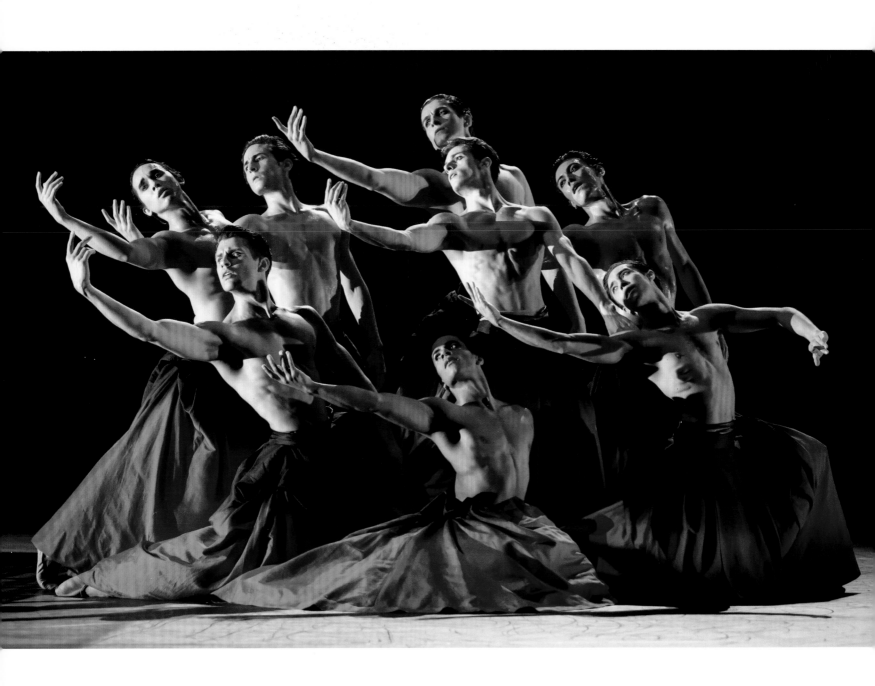

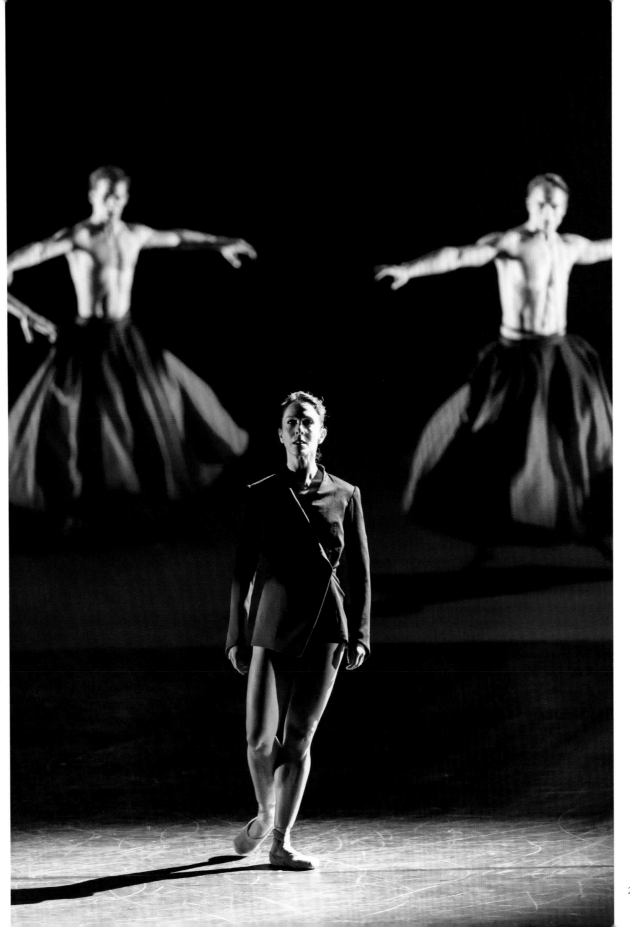

THE DREAM

Choreography
Frederick
Ashton

This page:
Steven McRae
as Oberon

Opposite page:
(*top*) Akane
Takada as
Titania, Bennet
Gartside
as Bottom;
(*bottom*)
Alexander
Campbell as
Oberon, Laura
Morera as
Titania and
with Artists
of The Royal
Ballet

©ROH 2017.
Photographs
by Tristram
Kenton

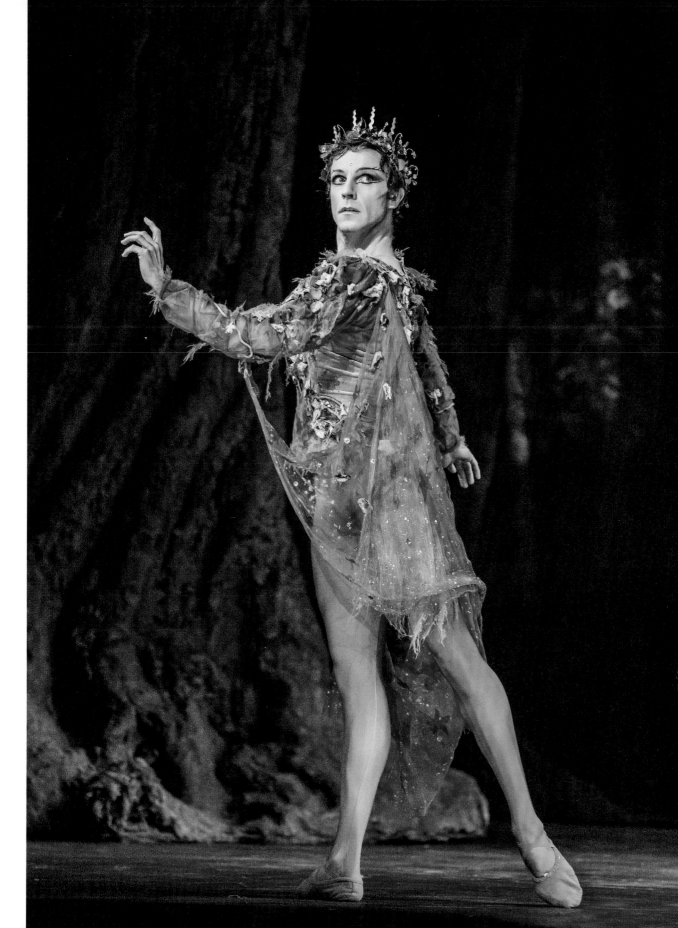

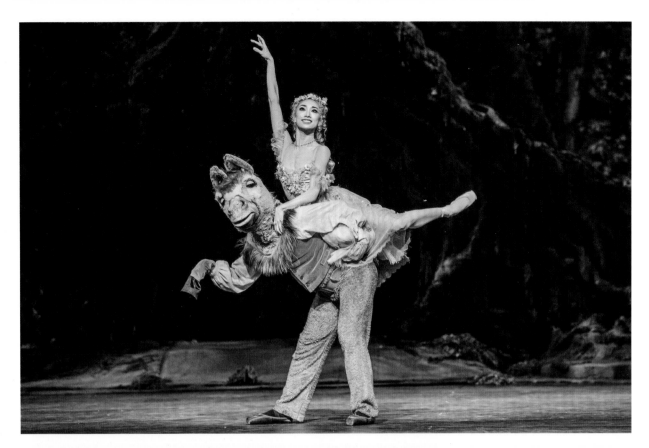

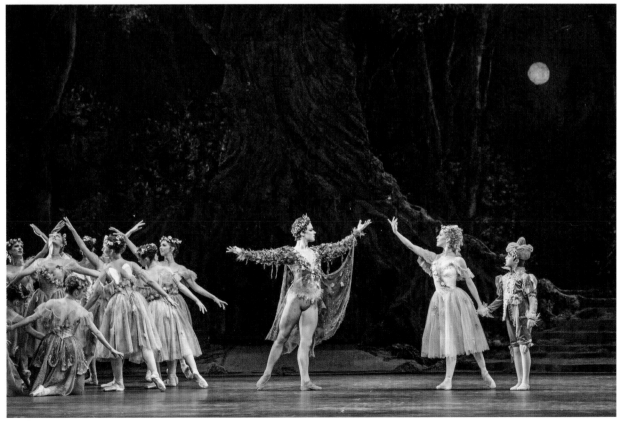

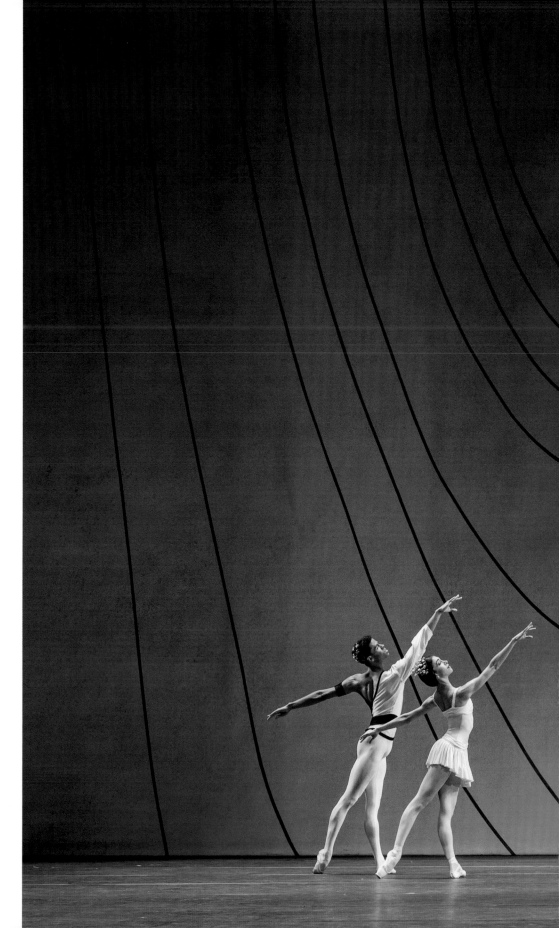

SYMPHONIC VARIATIONS

Choreography
Frederick Ashton

Joseph Sissens, Yasmine Naghdi, Reece Clarke, Lauren Cuthbertson, Benjamin Ella and Leticia Stock

©ROH 2017. Photograph by Tristram Kenton

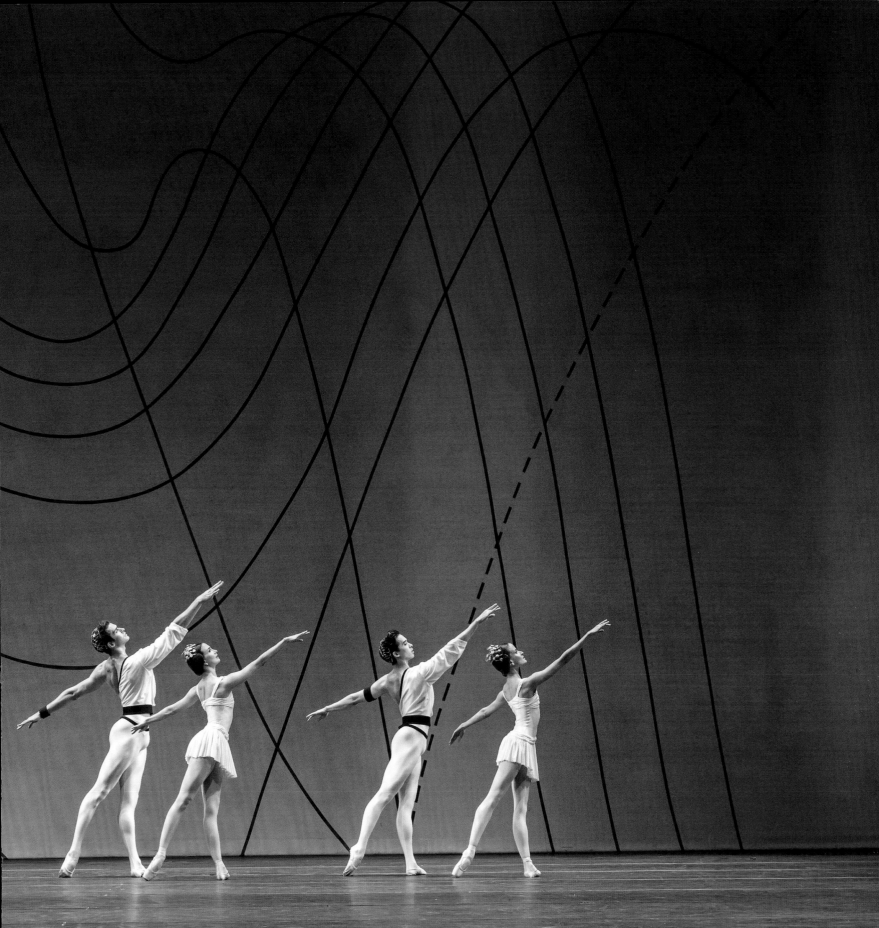

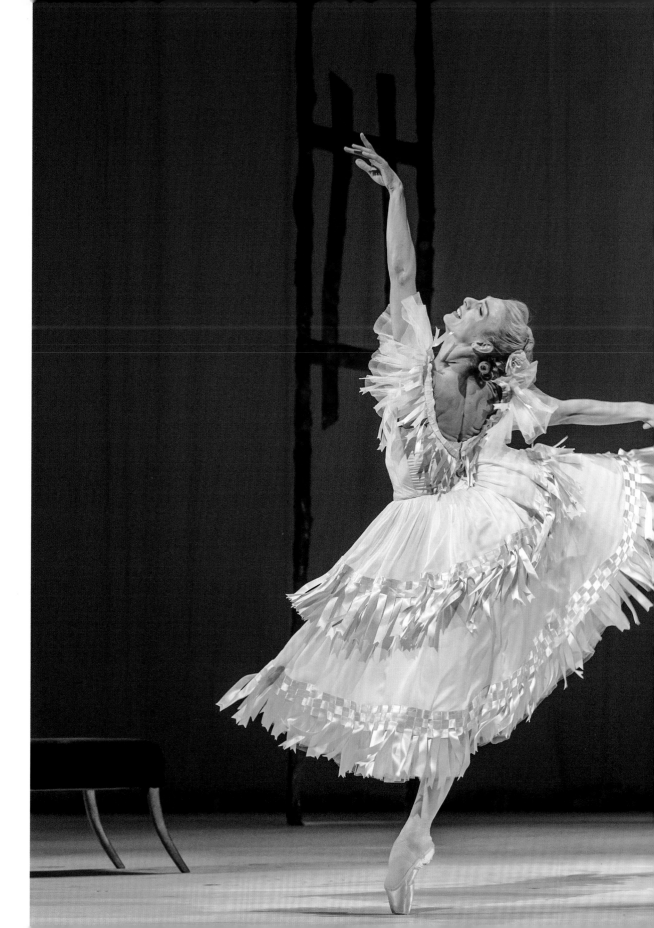

MARGUERITE AND ARMAND

Choreography
Frederick Ashton

Zenaida Yanowsky as Marguerite and Guest Artist Roberto Bolle as Armand

©ROH 2017. Photograph by Tristram Kenton

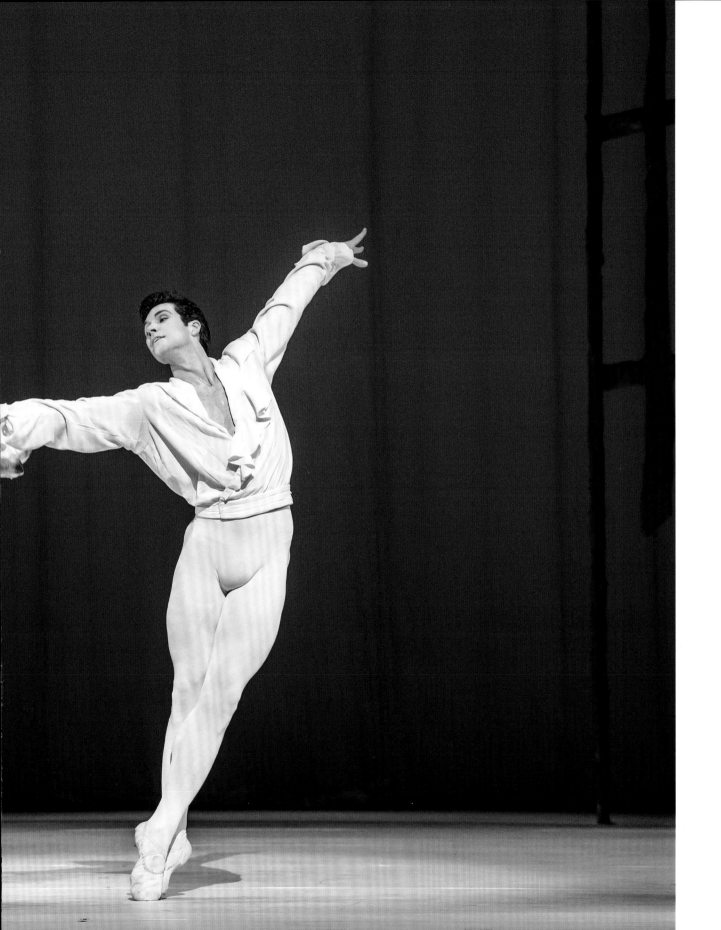

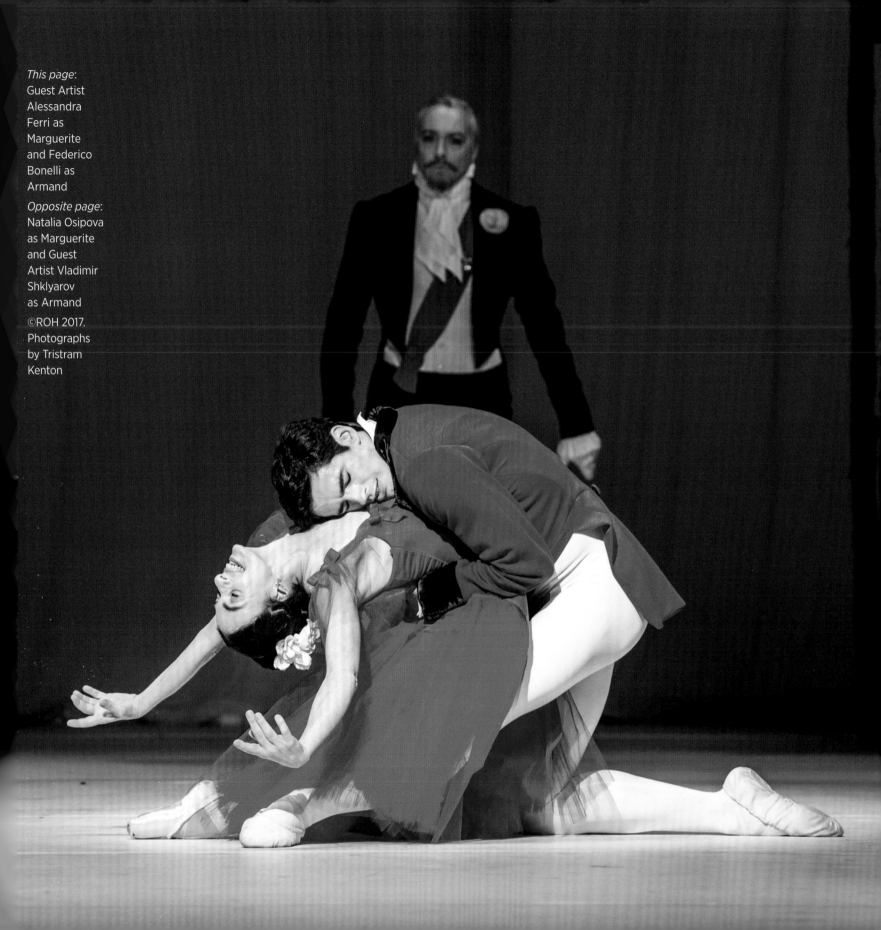

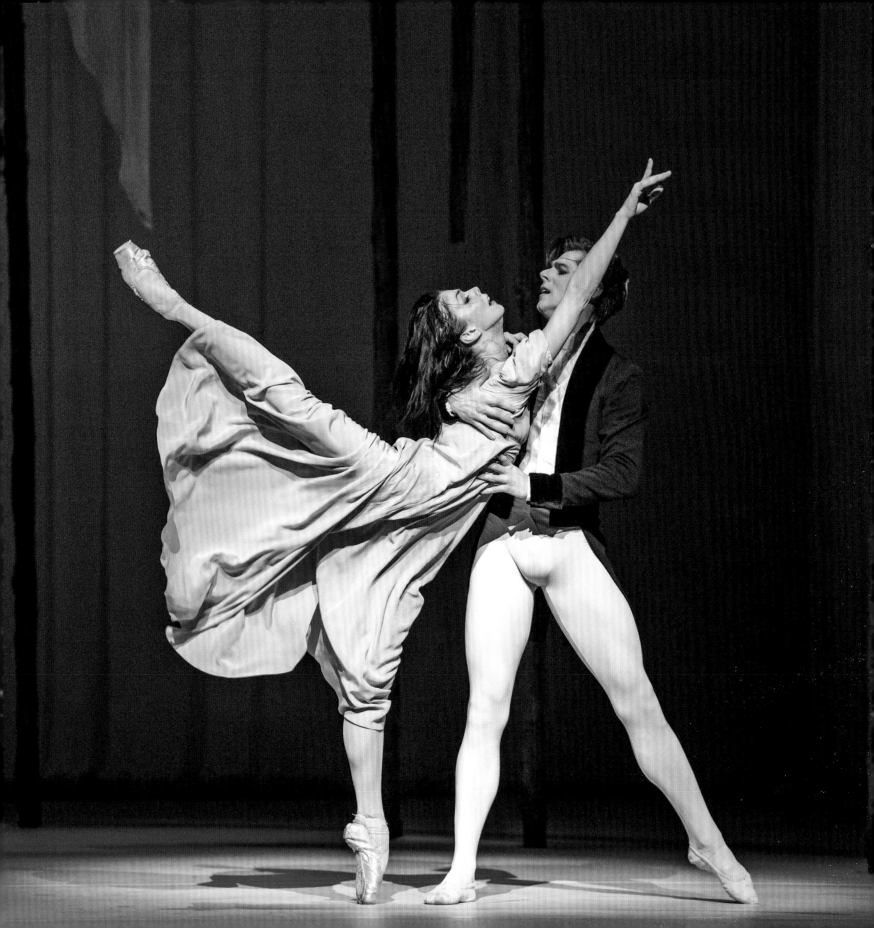

In rehearsal for Kenneth MacMillan's *Anastasia*

This page: (*top*) Lukas Bjørneboe Brændsrød, Thiago Soares and Thomas Whitehead; (*bottom*) Viviana Durante rehearses Laura Morera

Opposite page: Edward Watson and Natalia Osipova

©ROH 2016. Photographs by Tristram Kenton

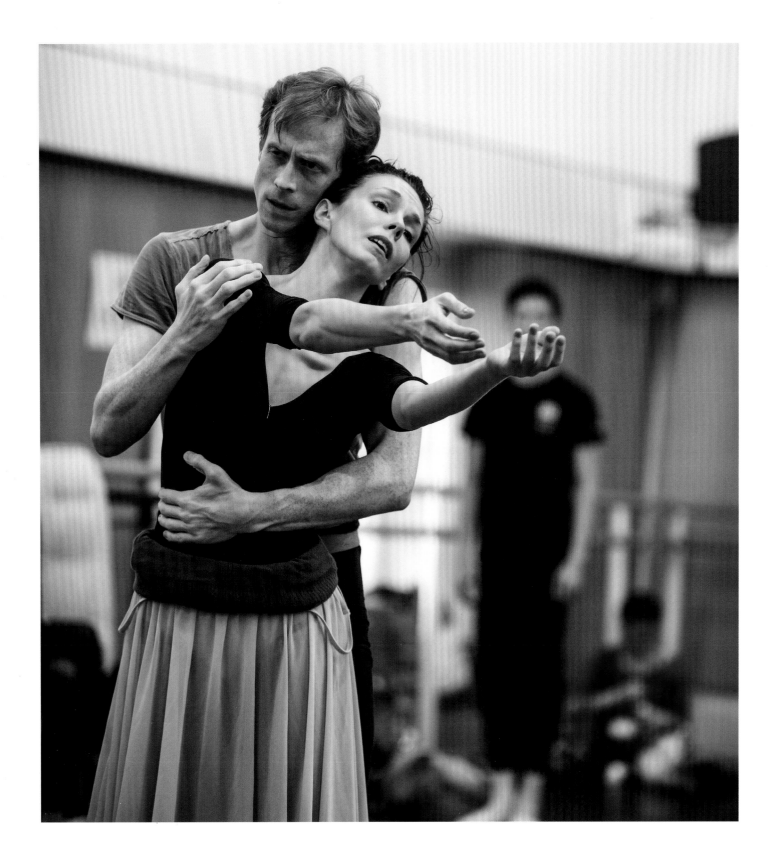

In rehearsal
for Wayne
McGregor's
Multiverse

This page:
Matthew Ball,
Sarah Lamb
and Paul Kay

Opposite page:
(*top*) Wayne
McGregor
rehearses
Olivia Cowley;
(*bottom*)
Steven McRae

©ROH 2016.
Photographs
by Andrej
Uspenski

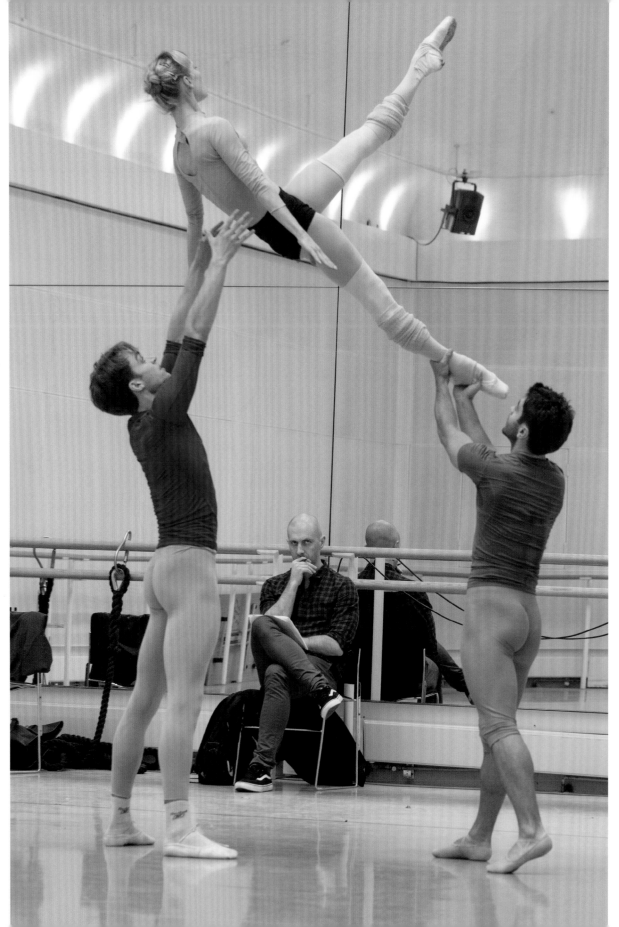

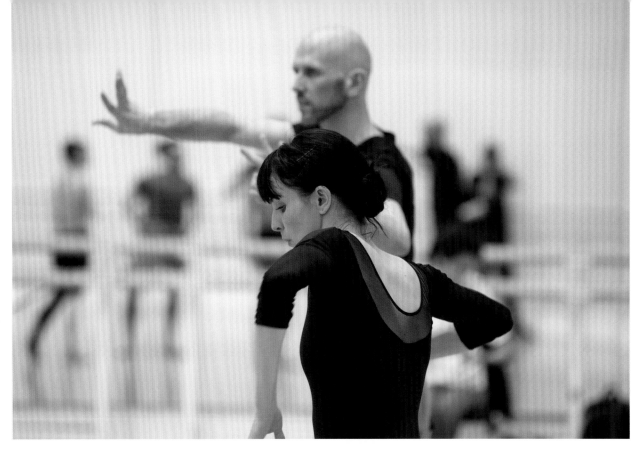

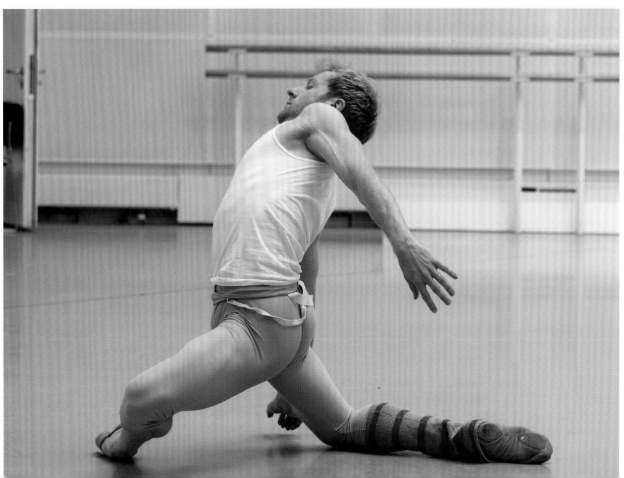

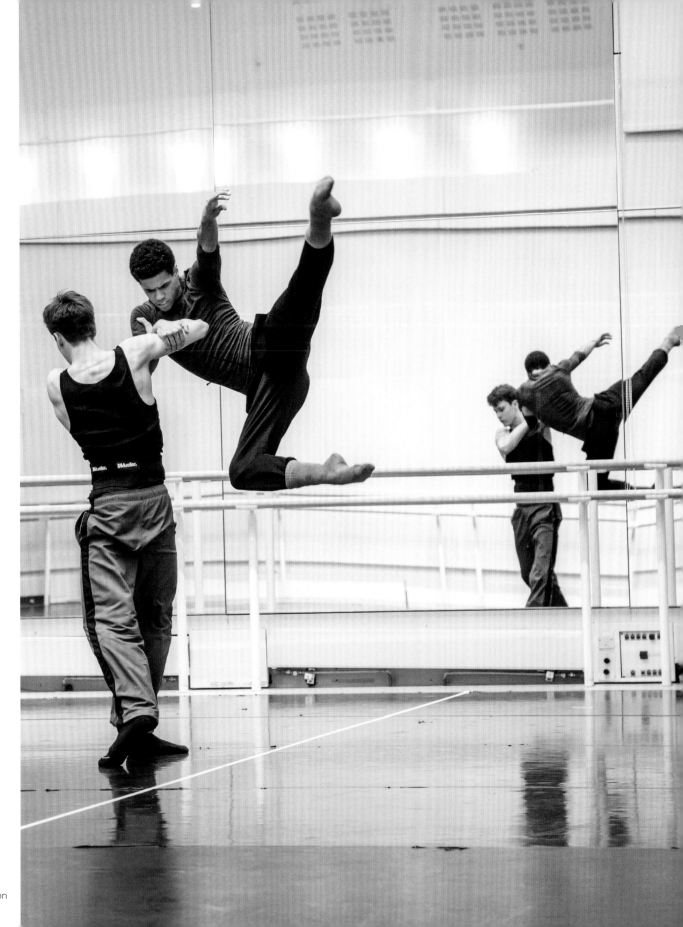

In rehearsal for Crystal Pite's *Flight Pattern*

This page: Calvin Richardson and Joseph Sissens

Opposite page: Marcelino Sambé and Kristen McNally

©ROH 2017. Photographs by Tristram Kenton

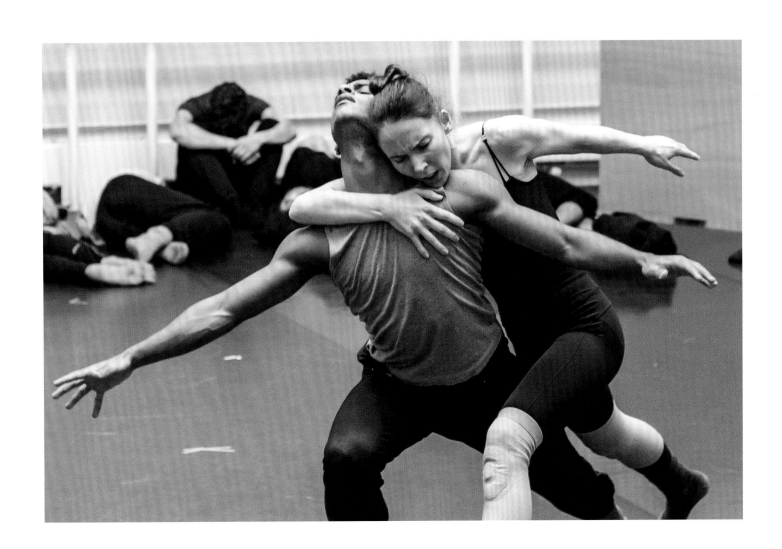

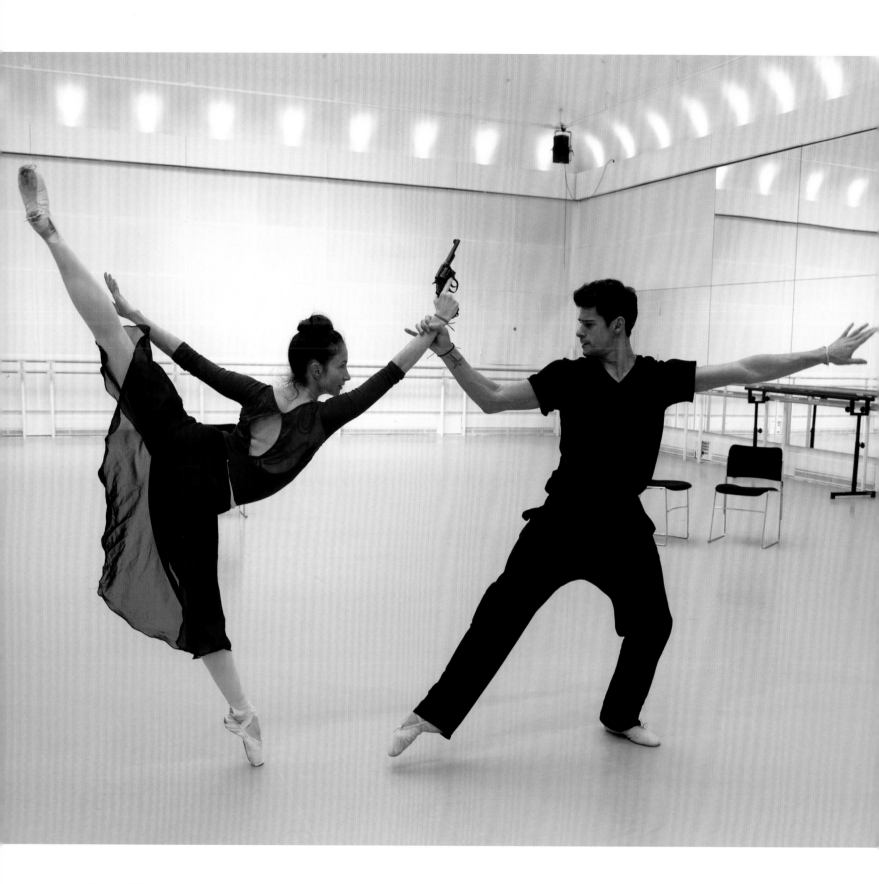

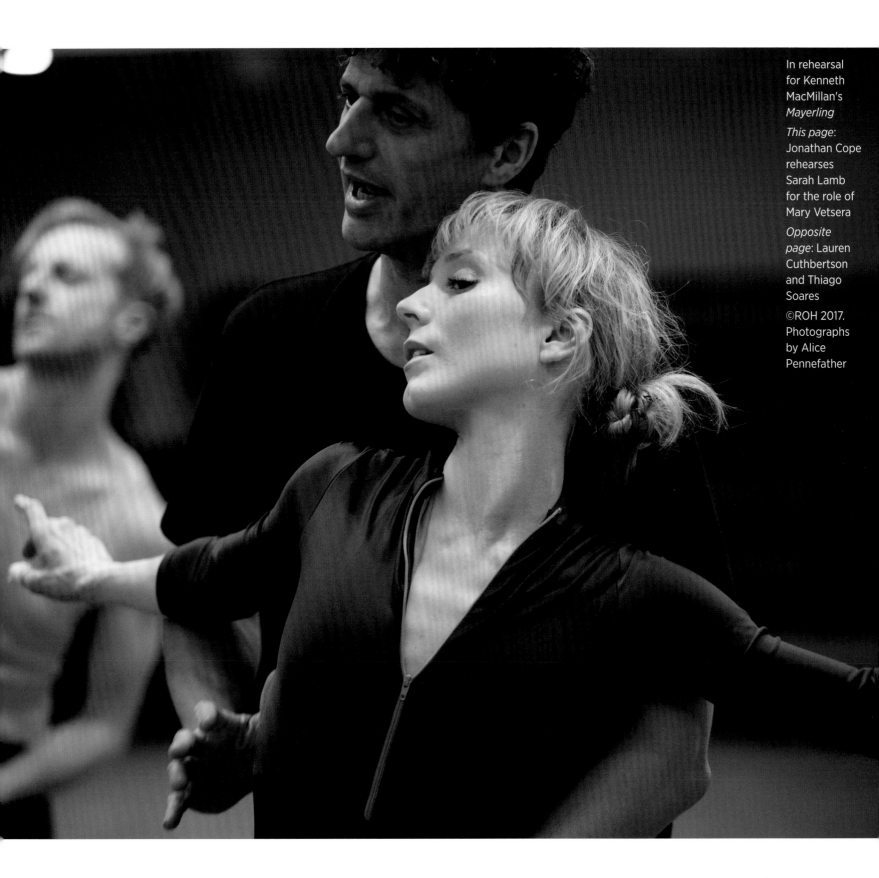

In rehearsal for Kenneth MacMillan's *Mayerling*

This page: Jonathan Cope rehearses Sarah Lamb for the role of Mary Vetsera

Opposite page: Lauren Cuthbertson and Thiago Soares

©ROH 2017. Photographs by Alice Pennefather

This page:
Vadim
Muntagirov
in rehearsal
for William
Forsythe's
*The Vertiginous
Thrill of
Exactitude*

Opposite page:
Valentino
Zucchetti
in rehearsal
for George
Balanchine's
Tarantella
©ROH 2017.
Photographs
by Bill Cooper

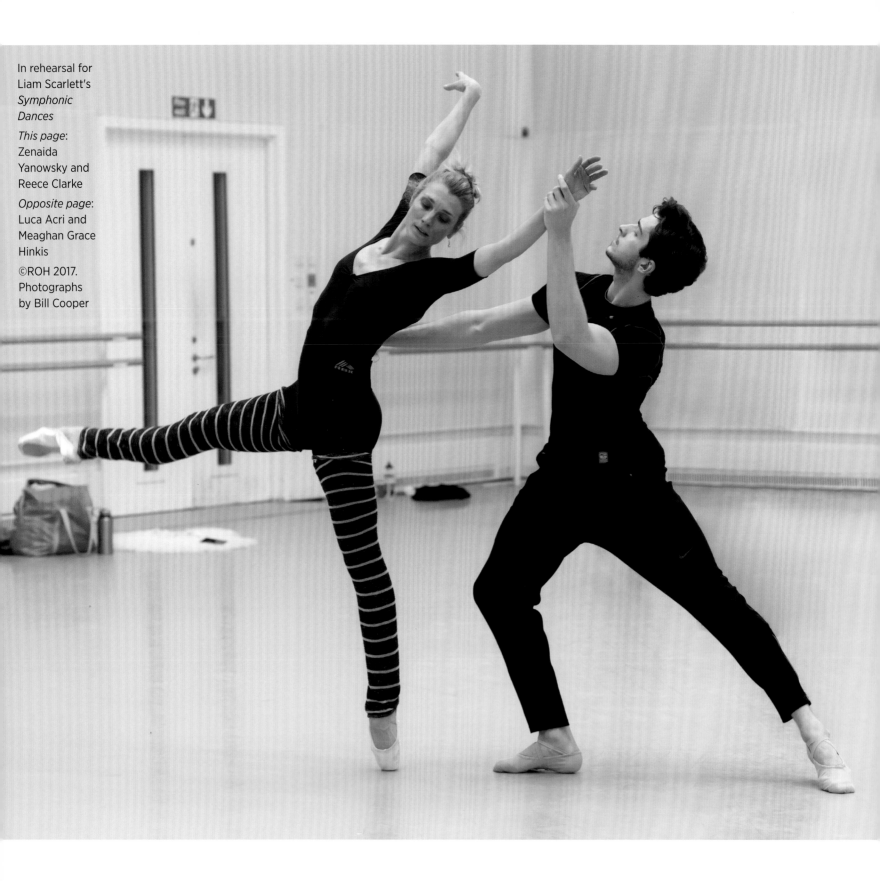

In rehearsal for Liam Scarlett's *Symphonic Dances*

This page: Zenaida Yanowsky and Reece Clarke

Opposite page: Luca Acri and Meaghan Grace Hinkis

©ROH 2017. Photographs by Bill Cooper

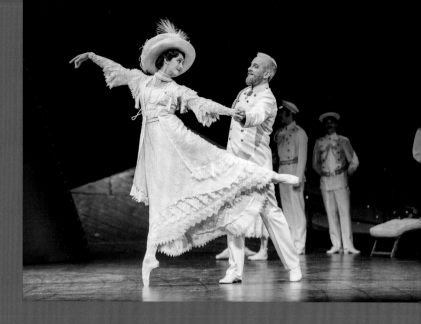

THE 2016/17 SEASON AT A GLANCE

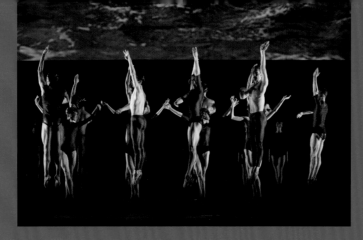

P. 36 THE MAD HATTER'S TEA PARTY
Director and writer Kate Prince
Choreography Members of ZooNation Dance Company
Music DJ Walde, Josh Cohen
Lyrics Josh Cohen, Kate Prince, DJ Walde
Set and costume designer Ben Stones
Lighting designer Andy Murrell
Sound designer Clement Rawling

Premiere
6 December 2014
(The Royal Ballet/ZooNation Dance Company)

P. 38 LES ENFANTS TERRIBLES
Direction and choreography Javier De Frutos
Music Philip Glass
Conductor Timothy Burke
Designer Jean-Marc Puissant
Lighting designer Bruno Poet
Video artist Tal Rosner

Premiere
27 January 2017
(The Royal Ballet)

P. 40 THE SLEEPING BEAUTY
Choreography Marius Petipa
Additional choreography Frederick Ashton, Anthony Dowell, Christopher Wheeldon
Production Monica Mason and Christopher Newton after Ninette de Valois and Nicholas Sergeyev
Music Pyotr Ilyich Tchaikovsky
Conductors Koen Kessels, Valeriy Ovsyanikov
Original designs Oliver Messel
Additional designs Peter Farmer
Lighting design Mark Jonathan
Staging Christopher Carr
Ballet Mistress Samantha Raine
Ballet Master Jonathan Howells
Assistant Ballet Mistress Sian Murphy
Principal Coaching Alexander Agadzhanov, Lesley Collier, Jonathan Cope, Viviana Durante, Olga Evreinoff, Christopher Saunders
Benesh Notators Gregory Mislin, Lorraine Gregory

Premieres
20 February 1946
(Sadler's Wells Ballet)

15 May 2006
(The Royal Ballet, this production)

P. 44 WOOLF WORKS
Concept and direction Wayne McGregor
Choreography Wayne McGregor
Music Max Richter
Conductor Koen Kessels
Designers Ciguë, We Not I, Wayne McGregor
Costume designer Moritz Junge
Lighting designer Lucy Carter
Film designer Ravi Deepres
Sound designer Chris Ekers
Make-up designer Kabuki
Dramaturgy Uzma Hameed
Staging Wayne McGregor, Amanda Eyles, Jenny Tattersall
Assistants to the Choreographer Amanda Eyles, Jenny Tattersall
Ballet Master Gary Avis
Assistant Ballet Mistress Sian Murphy
Benesh Notator Amanda Eyles

Premiere
11 May 2015
(The Royal Ballet)

P. 48 THE HUMAN SEASONS
Choreography David Dawson
Music Greg Haines
Conductor Koen Kessels
Set and projection designer Eno Henze
Costume designer Yumiko Takeshima
Lighting designer Bert Dalhuysen
Staging Tim Couchman
Ballet Master Jonathan Howells

Premiere
9 November 2013
(The Royal Ballet)

P. 50 AFTER THE RAIN
Choreography Christopher Wheeldon
Music Arvo Pärt
Conductor Koen Kessels
By arrangement with Universal Edition A.G. Wien
Costume designer Holly Hynes
Lighting designers 59 Productions
Staging and Ballet Master Christopher Saunders

Premieres
22 January 2005
(New York City Ballet)

30 October 2012
(The Royal Ballet)

P. 52 FLIGHT PATTERN
Choreography Crystal Pite
Music Henryk Mikolaj Górecki
Conductor Koen Kessels
by arrangement with Chester Music Limited on behalf of Polskie Wydawnictwo Muzyczne
Set designer Jay Gower Taylor
Costume designer Nancy Bryant
Lighting designer Tom Visser
Assistant to the choreographer Deirdre Chapman
Benesh Notator Gregory Mislin

Premiere
16 March 2017
(The Royal Ballet)

This page:
(top) Artists of The Royal Ballet in *Woolf Works*
©ROH 2017. Photograph by Andrej Uspenski

(bottom left) Yasmine Naghdi as Princess Aurora and Matthew Ball as Prince Florimund in *The Sleeping Beauty*
©ROH 2017. Photograph by Bill Cooper

(bottom right) Marianela Nuñez and Thiago Soares in *After the Rain*
©ROH 2017. Photograph by Tristram Kenton

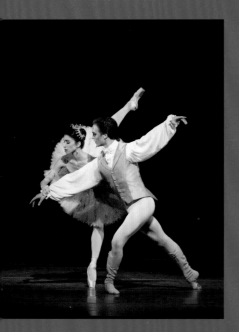

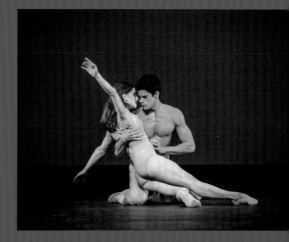

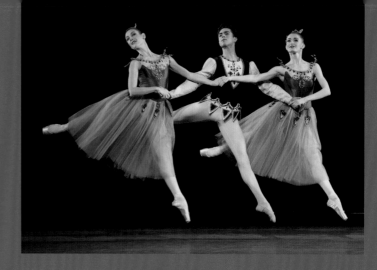

This page: (*top*) Helen Crawford, James Hay and Anna Rose O'Sullivan in 'Emeralds' from *Jewels*; (*bottom*) Elizabeth McGorian as Baroness Helene Vetsera and Hikaru Kobayashi as Mary Vetsera in *Mayerling* ©ROH 2017. Photographs by Alice Pennefather

P. 56 JEWELS
Choreography George Balanchine ©The George Balanchine Trust
Music Gabriel Fauré ('Emeralds'), Igor Stravinsky ('Rubies'), Pyotr Ilyich Tchaikovsky ('Diamonds')
Conductor Pavel Sorokin
Set designer Jean-Marc Puissant
Costume designer Barbara Karinska
Costume design consultant Holly Hynes
Lighting Jennifer Tipton

Premieres
13 April 1967
(New York City Ballet)

23 November 2007
(The Royal Ballet, this production)

P. 58 MAYERLING
Choreography Kenneth MacMillan
Music Franz Liszt
Arranged and orchestrated by John Lanchbery
Conductor Martin Yates
Designer Nicholas Georgiadis
Scenario Gillian Freeman
Lighting designer John B. Read
Staging Christopher Saunders, Grant Coyle, Karl Burnett
Ballet Masters Christopher Saunders, Gary Avis
Ballet Mistress Samantha Raine
Assistant Ballet Mistress Sian Murphy
Principal Coaching Alexander Agadzhanov, Leanne Benjamin, Ricardo Cervera, Jonathan Cope, Jonathan Howells
Benesh Notators Karl Burnett, Grant Coyle

Premiere
14 February 1978
(The Royal Ballet)

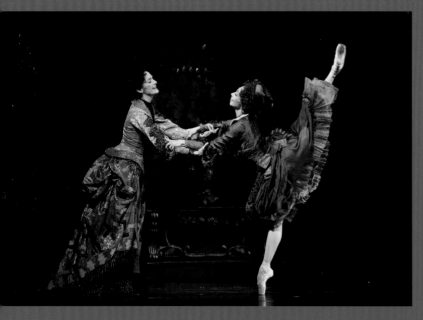

P. 62 THE VERTIGINOUS THRILL OF EXACTITUDE
Choreography William Forsythe
Music Franz Schubert
Conductor Koen Kessels
Costume designer Stephen Galloway
Lighting designer Tanja Rühl
Staging Kathryn Bennetts
Ballet Mistress Samantha Raine

Premieres
20 January 1996
(Frankfurt Ballet)

23 November 1999
(The Royal Ballet)

P. 64 TARANTELLA
Choreography George Balanchine ©The George Balanchine Trust
Music Louis Moreau Gottschalk Given by permission of Boosey & Hawkes Music Publishers Limited
Orchestration Hershy Kay
Conductor Koen Kessels
Costume designer Karinska
Costume designs realized by Natalia Stewart
Lighting designer Simon Bennison
Staging Patricia Neary
Ballet Mistress Samantha Raine
Benesh Notator Lorraine Gregory

Premieres
7 January 1964
(New York City Ballet)

18 May 2017
(The Royal Ballet)

P. 66 STRAPLESS
Choreography Christopher Wheeldon
Scenario Christopher Wheeldon and Charlotte Westenra
Inspired by the book by Deborah Davis
Music Mark-Anthony Turnage Given by permission of Boosey & Hawkes Music Publishers Limited
Additional orchestrations Christopher Austin
Conductor Koen Kessels
Designer Bob Crowley
Lighting designer Natasha Chivers
Assistant to the choreographer Jacquelin Barrett
Ballet Master Jonathan Howells
Benesh Notator Anna Trevien

Premiere
12 February 2016
(The Royal Ballet)

P. 68 SYMPHONIC DANCES

Choreography Liam Scarlett
Music Sergey Rachmaninoff
Conductor Koen Kessels
Designer Jon Morrell
Lighting designer David Finn
Video designers David Finn,
Leo Flint
Ballet Master Ricardo Cervera
Assistant Ballet Mistress
Sian Murphy
Benesh Notator Gregory Mislin

Premiere
18 May 2017
(The Royal Ballet)

P. 72 THE DREAM

Choreography Frederick Ashton
Music Felix Mendelssohn
Arranged by John Lanchbery
Conductor Emmanual Plasson
Designer David Walker
Lighting designer John B. Read
Staging Anthony Dowell,
Christopher Carr
Ballet Mistress Samantha Raine
Ballet Master Jonathan Howells
Principal Coaching Anthony Dowell,
Lesley Collier

Premiere
2 April 1964
(The Royal Ballet)

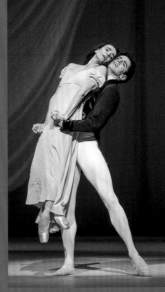

P. 74 SYMPHONIC VARIATIONS

Choreography Frederick Ashton
Music César Franck
Conductor Emmanual Plasson
Designer Sophie Fedorovitch
Lighting designer John B. Read
Staging Wendy Ellis Somes,
Malin Thoors
Ballet Master Ricardo Cervera

Premiere
24 April 1946
(Sadler's Wells Ballet)

P. 76 MARGUERITE AND ARMAND

Choreography Frederick Ashton
Music Franz Liszt
Orchestration Dudley Simpson
Conductor Emmanual Plasson
Orchestration Dudley Simpson
Designer Cecil Beaton
Lighting designer John B. Read
Staging Grant Coyle
Principal Coaching Alexander
Agadzhanov, Jonathan Cope
Benesh Notator Grant Coyle

Premiere
12 March 1963
(The Royal Ballet)

Orchestra of the Royal Opera House

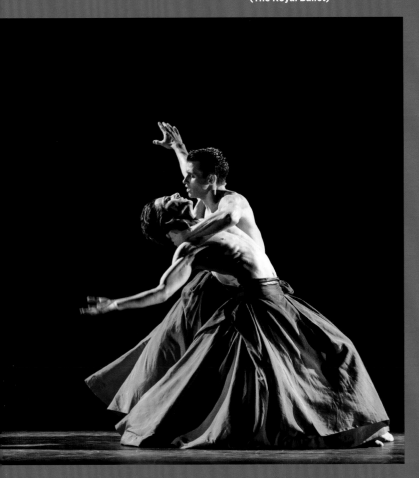

**THE ROYAL BALLET 2017
TOUR TO AUSTRALIA**

*Lyric Theatre, Queensland Performing
Arts Centre, Brisbane*
**WOOLF WORKS
THE WINTER'S TALE**

Munro Martin Parklands, Cairns
GALA PERFORMANCE
Including:
Voices of Spring, Nisi Dominus,
Asphodel Meadows pas de deux,
Swan Lake pas de deux, Qualia pas
de deux, Romeo and Juliet balcony
pas de deux, The Dying Swan solo,
Tarantella, Manon pas de deux,
After the Rain pas de deux,
Don Quixote pas de deux

This page:
(*top*)
Alessandra
Ferri as
Marguerite
and Federico
Bonelli as
Armand in
*Margeurite
and Armand*

© ROH 2017.
Photograph
by Tristram
Kenton

(*bottom*)
Nicol Edmonds
and Tristan
Dyer in
*Symphonic
Dances*

©ROH 2017.
Photograph
by Bill Cooper

THE ROYAL BALLET AND ITS HERITAGE: STYLE AND TRADITION BY SARAH CROMPTON

Many twisting strands make up the story of a ballet company. Looking at a chronology, it's possible to imagine a direct ascent towards a goal, a sunny, upward progress, an unbroken span of success. But unpicking the threads of the narrative, different patterns forged of people, places and things begin to emerge.

The Royal Ballet's relatively short lifespan – at 86 it is a stripling compared with the centuries-long traditions of the Paris Opera Ballet (founded in 1669) and the Mariinsky (formed in 1740) – means that its history looks simple to read. Its redoubtable founder Ninette de Valois was fond of making it look as straightforward as possible. When the critic Clement Crisp suggested that she must have had great vision to transform a troupe of six dancers working on a pittance into a world-class company in the space of less than 20 years, she was dismissive: 'Women are housekeepers,' she told him, 'And I learnt to take every opportunity that was presented.'

This rather ignores the fact that as early as 1921, she wanted to found her own company and set about learning how to do that with considerable resolve. Her greatest inspiration was the two and a half years she spent dancing for Diaghilev's Ballets Russes, from which she emerged in 1927 impressed by the model of 'a repertory company running classical and modern ballet side by side – and what is more important – in many cases blended.'

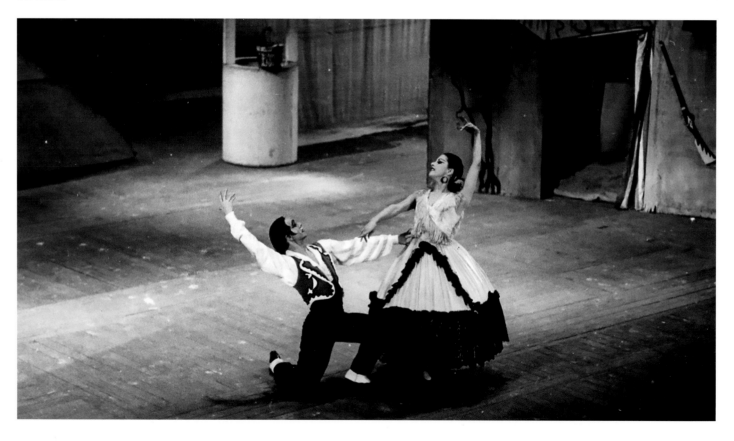

Company Chronology

1931 **20 January** Bizet's opera *Carmen* is staged at the newly reopened Sadler's Wells Theatre with dancers from a fledgling ballet company, the Vic-Wells Opera Ballet, under the creative direction of their founder Ninette de Valois. The product of many developments of this company is today's Royal Ballet. **5 May** The Company gives a performance of short works by De Valois at Lilian Baylis's Old Vic theatre. Baylis's use of dancers in operas and plays enables De Valois to bring her emerging Company together. **July** The Camargo Society presents the Company in a programme that includes De Valois's *Job* and two works by Frederick Ashton, a young dancer also beginning to choreograph.

1932 **January** Alicia Markova becomes a regular Guest Artist with the Company, alongside Anton Dolin. **March** Revival of *Les Sylphides* with Markova and Dolin. **September** The Company tours for the first time, to Denmark. **October** The Company first performs classical repertory with Act II of *Le Lac des cygnes*.

1933 **March** Nicholas Sergeyev stages a full-length *Coppélia*, with Lydia Lopokova as Swanilda. Sergeyev, former *régisseur général* of the Mariinsky Theatre, brought written notation of classic Russian ballets to the West after fleeing Russia in the wake of the October Revolution.

1934 **January** Sergeyev stages *Giselle*, with Markova and Dolin. **April** Sergeyev stages *Casse-Noisette*. **20 November** The Company performs *Le Lac des cygnes* in full, with Markova and new Company Principal Robert Helpmann.

1935 Ashton becomes Resident Choreographer. **20 May** Premiere of De Valois's *The Rake's Progress*, with Markova as the Betrayed Girl. **26 November** Premiere of Ashton's *Le Baiser de la fée*. The cast includes the young Margot Fonteyn.

1937 The Company represents British culture at the International Exhibition in Paris. Their performances include the premiere of De Valois's *Checkmate*. **16 February** Premiere of Ashton's *Les Patineurs*. **27 April** Premiere of Ashton's *A Wedding Bouquet*. **5 October** London premiere of *Checkmate*.

1939 **2 February** Sergeyev stages *The Sleeping Princess*, with Fonteyn and Helpmann.3

1940 **23 January** Premiere of Ashton's *Dante Sonata*. **May** The Company tours to the Netherlands. **November** The Company begins wartime tours throughout Britain.

1941 The New Theatre, St Martin's Lane, becomes the Company's home for much of the war. *The Sleeping Princess* is revived.

1942 **19 May** Premiere of Helpmann's ballet *Hamlet*, with Helpmann in the title role.

1944 **26 October** Premiere of Helpmann's *Miracle in the Gorbals*.

1945 The Company tours the Continent with the Entertainments National Service Association (ENSA).

1946 **20 February** The Company becomes resident at Covent Garden, and after the War reopens the Royal Opera House with *The Sleeping Beauty*. **24 April** Premiere of Ashton's *Symphonic Variations*.

1947 **February** *The Three-Cornered Hat* and *La Boutique fantasque* are revived by Léonide Massine, one of the biggest stars of Diaghilev's Ballets Russes, at De Valois's invitation.

1948 **23 December** Premiere of Ashton's *Cinderella*, the Company's first home-grown full-length ballet.

1949 **9 October** The Company performs *The Sleeping Beauty* in New York at the start of a hugely successful tour to many cities in the USA and Canada.

1950 **20 February** Premiere of De Valois's production of *Don Quixote*. **5 April** George Balanchine and his New York City Ballet make their first European visit. Balanchine revives his *Ballet Imperial* for the Company. **5 May** Premiere of Roland Petit's *Ballabile*. **September** The Company embarks on a five-month, 32-city tour of the USA.

1951 **21 August** Music Director Constant Lambert dies, aged 45. With De Valois and Ashton, Lambert was one of the chief architects of the Company.

1952 **3 September** Premiere of Ashton's *Sylvia*.

1953 **2 June** Premiere of Ashton's *Homage to the Queen*, as part of a coronation gala for HM The Queen.

1954 **23 August** The Company performs *The Firebird* at the Edinburgh Festival on the 25th anniversary of Diaghilev's death. Margot Fonteyn takes the title role.

1956 1 March Premiere of Kenneth MacMillan's *Noctambules*, his first ballet for the Company. **31 October** Sadler's Wells Ballet, Sadler's Wells Theatre Ballet and the School are granted a Royal Charter. The main Company becomes The Royal Ballet.

1957 1 January Premiere of John Cranko's *The Prince of the Pagodas*, with a new score by Benjamin Britten. This is the Company's first full-length work to a commissioned score.

1958 27 October Premiere of Ashton's *Ondine*, with a new score by Hans Werner Henze and Fonteyn in the title role.

1959 13 March Company premiere of MacMillan's *Danses concertantes*, created for Sadler's Wells Theatre Ballet in 1955.

1960 28 January Premiere of Ashton's *La Fille mal gardée*, with Nadia Nerina and David Blair.

1961 15 June The Company performs *Ondine* in Leningrad at the start of a tour to the USSR. The Kirov Ballet perform at Covent Garden as part of an exchange agreement. **14 February** The Royal Ballet Touring Company gives the premiere of Ashton's *Les Deux Pigeons* (later *The Two Pigeons*) with Lynn Seymour as Gourouli (later The Young Girl), Christopher Gable as Pepino (later The Young Man) and Elizabeth Anderton as the Gypsy Girl.

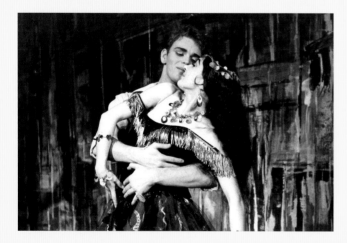

That is what she set out to create, and in a radio interview at the end of her life, she expressed her gratitude for the way Diaghilev had shaped her ideas. 'You came up against everything there,' she said, talking about the sense of creative ferment. '...What could I do but stand and sort it out like a jigsaw puzzle, and realize that we had absolutely *nothing* in England and all I wanted to do was to get back and start *something*.'

Her determination from that point on was something to behold, as by sheer force of will she dragged that something into being. Julia Farron, who was the first pupil to win a scholarship to the Vic Wells School that De Valois founded, and subsequently joined the company in 1936 at the age of 14, remembers: 'She was that sort of woman. If she wanted to do something, she was going to do it.'

De Valois gathered around her, and cemented to her side, the best of talent she could find to bolster her fledgling company, including Constant Lambert as conductor and Musical Director, and Frederick Ashton, whom she enticed away from Marie Rambert and appointed as Resident Choreographer as early as 1935. Later, she gave up her own choreographic time to nurture the abilities of Kenneth MacMillan. She was lucky their talents existed; but she did everything she could to make sure their creativity served her vision. She made her own luck. Beryl Grey, another of her young protégés remembers her as 'living on a wonderful star which reflected on all of us.'

The most major opportunity she seized was the apparent disaster of World War II, the event that for all its hardship forged the Vic Wells ballet into a company that was ready to take on all comers. The relentless touring, the nine shows a week in the West End, built an audience for dance that had not existed in Britain before. 'We went to all sorts of places,' says Grey. 'We danced in every city. People needed to be taken out of the horrors of war, and I think ballet perhaps, more than anything else because it wasn't using words, was somehow inspiring and refreshing and enjoyable.'

The constant dancing might have been exhausting but it also honed the dancers into performers capable of rising to the most arduous physical challenge. When the fighting ended and the Company was invited into the Royal Opera House, they were ready. Ashton was there to stamp onto the Company a style that is now regarded as English, with its quick feet and a contrapuntal flow of movement that made dancers look as if they were really dancing. Peter Wright, whose own versions of the classics have done so much to build on that style, remembers: 'He was always poking you in the back, and saying, "Use your back, use your

1962 21 February Rudolf Nureyev makes his Company debut in *Giselle* with Fonteyn, after his controversial defection from the Kirov in 1961. **3 May** Premiere of MacMillan's *The Rite of Spring*, with Monica Mason. **16 October** The Royal Ballet first performs Ashton's *The Two Pigeons*, with Lynn Seymour, Alexander Grant and Georgina Parkinson in the main roles.

1963 12 March Premiere of Ashton's *Marguerite and Armand*, with Fonteyn and Nureyev. **7 May** De Valois retires as Director of the Company, succeeded by Ashton. De Valois becomes Supervisor of The Royal Ballet School. **28 November** Nureyev stages the 'Kingdom of the Shades' scene from *La Bayadère*.

1964 29 February Antoinette Sibley dances Princess Aurora in the Company's 400th performance of *The Sleeping Beauty*. **2 April** Premiere of Ashton's *The Dream*, with Sibley and Anthony Dowell, as part of celebrations of the 400th anniversary of Shakespeare's birth. **2 December** Bronislava Nijinska revives her *Les Biches*, with Svetlana Beriosova as the Hostess.

1965 9 February Premiere of MacMillan's first full-length work, *Romeo and Juliet*, created on Lynn Seymour and Christopher Gable but danced on opening night by Fonteyn and Nureyev.

1966 23 March Nijinska revives her *Les Noces* in a mixed programme with *Les Biches*. **May** MacMillan becomes Director of Deutsche Oper Ballet, Berlin. **19 May** Company premiere of MacMillan's *Song of the Earth*, created for Cranko's Stuttgart Ballet in 1965.

1967 25 January Premiere of Antony Tudor's *Shadowplay* with Anthony Dowell as the boy with the matted hair.

1968 29 February Premiere of Nureyev's staging of *The Nutcracker*. **26 April** Announcement of Ashton's retirement as Director in 1970 and his succession by MacMillan. **25 October** Premiere of Ashton's *Enigma Variations*.

1971 22 July Premiere of MacMillan's long-awaited *Anastasia*, with Seymour. **4 August** Premiere of Glen Tetley's contemporary ballet *Field Figures*.

1972 20 June Natalia Makarova makes her Company debut as a Guest Artist in *Giselle*, with Dowell.

1973 8 June Nureyev and Makarova dance *The Sleeping Beauty* together for the first time.

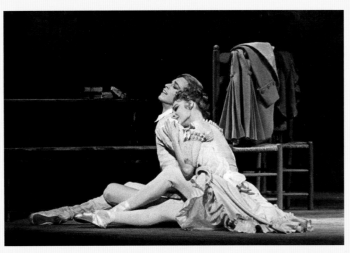

1974 7 March Premiere of MacMillan's *Manon*, with Sibley, Dowell and David Wall. **7 October** Premiere of MacMillan's *Elite Syncopations*, with Wayne Sleep in the Principal Character role.

1975 April The Royal Ballet makes its first tour of the Far East.

1976 12 February Premiere of Ashton's *A Month in the Country*, with Dowell and Seymour.

1977 13 June Norman Morrice succeeds MacMillan as Director of The Royal Ballet.

1978 14 February Premiere of MacMillan's *Mayerling*, with Wall and Seymour.

1980 13 March Premiere of MacMillan's *Gloria*. **4 August** Premiere of Ashton's *Rhapsody*, with Lesley Collier and Mikhail Baryshnikov, in celebration of the 80th birthday of HM Queen Elizabeth The Queen Mother.

1981 30 April Premiere of MacMillan's *Isadora* with Merle Park, in celebration of the Company's golden jubilee.

1982 2 December Premiere of Nureyev's *The Tempest*.

1984 24 February Premiere of MacMillan's *Different Drummer*. **20 December** Premiere of Peter Wright's production of *The Nutcracker*, with Collier and Dowell.

1986 Dowell succeeds Morrice as Director of The Royal Ballet.

1987 12 March Premiere of Dowell's production of *Swan Lake*, with Cynthia Harvey and Jonathan Cope. **16 December** Ashton revives his *Cinderella*, in his final production for the Company.

This page: Antoinette Sibley as Manon and Anthony Dowell as Des Grieux in MacMillan's *Manon*
©Leslie E. Spatt 1974

Opposite page: Christopher Gable as The Young Man and Elizabeth Anderton as A Gypsy Girl in Ashton's *Les Deux Pigeons* (The Royal Ballet Touring Company, 1961)
© ROH. Photograph by Donald Southern

1988 9 March Premiere of David Bintley's *'Still Life' at the Penguin Café*. **10 May** Revival of Ashton's *Ondine*, after a 22-year absence from the repertory. **19 August** Ashton dies.

1989 18 May Company premiere of the full-length *La Bayadère*, in a staging by Makarova. **8 December** Premiere of MacMillan's final, full-length ballet, *The Prince of the Pagodas*, with Darcey Bussell and Cope.

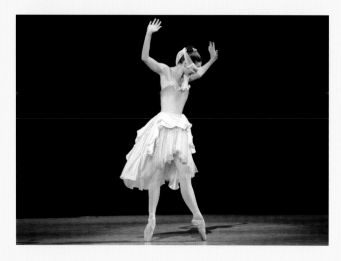

1990 19 July Bussell and Irek Mukhamedov perform MacMillan's 'Farewell' pas de deux at a London Palladium gala.

1991 7 February Premiere of MacMillan's *Winter Dreams* (developed from the 'Farewell' pas de deux). **2 May** Premiere of Bintley's *Cyrano*, in celebration of the Company's 60th anniversary.

1992 13 February Company premiere of William Forsythe's *In the middle, somewhat elevated*. **19 March** Premiere of MacMillan's last work, *The Judas Tree*, with Viviana Durante and Mukhamedov. **29 October** MacMillan dies backstage at the Royal Opera House during a revival of *Mayerling*. **6 December** Stage premiere of Ashton's *Tales of Beatrix Potter*.

back." It made everything look effortless – defying gravity, no strain, all flow.'

The exemplar of that style was Margot Fonteyn, the home-grown ballerina who burnished the reputation of what came to be called The Royal Ballet. On the legendary 1949 tour to the United States, when the Company opened a four-week season at the Metropolitan Opera House with its hallmark production of *The Sleeping Beauty*, it was Moira Shearer – famous from *The Red Shoes* – that people wanted to see. But it was Fonteyn who triumphed – 'a vision of potential' according to Maria Tallchief, ballerina of New York City Ballet.

Fonteyn's dominance was fading by 1961 when a comet arrived from the East in the form of Rudolf Nureyev. De Valois made the most of the opportunity once more, offering him a home at The Royal Ballet and in the process revitalizing her star ballerina and making British ballet in the 1960s almost as sexy and compelling as The Beatles and The Rolling Stones. In this context, another generation of dancers began to emerge – Antoinette Sibley, Anthony Dowell, Lynn Seymour, Christopher Gable, Svetlana Beriosova, Donald MacLeary, Merle Park, David Wall – different from their predecessors, but just as dazzling.

Nothing, however, is ever simple. Nureyev and Fonteyn's box office appeal led to one of the greatest rows in Royal Ballet history, when they replaced Seymour and Gable as the opening night cast of *Romeo and Juliet* in 1964 – opening wounds that took time to heal. Yet the triumph of MacMillan's first three-act ballet confirmed him as the new dominant choreographic voice in British ballet. 'His contribution is huge,' says Peter Wright. 'He broke down the barriers more than anyone, bringing in different and more contemporary movement.'

His influence is also responsible for the other quality that would be regarded as part of the Royal Ballet style – an extremely naturalistic sense of drama and complete involvement in every role, however minor. Senior Ballet Master Christopher Saunders remembers rehearsing under MacMillan's watchful eye. 'It was all about naturalism,' he says. 'He wouldn't say much, but he would tell Paris, for example, to look in Juliet's eyes when he kisses her hand. Little details like that, rather than explaining how people were thinking. And he loved people to walk naturally. He didn't want them to walk like ballet princes, and it is very hard not to.'

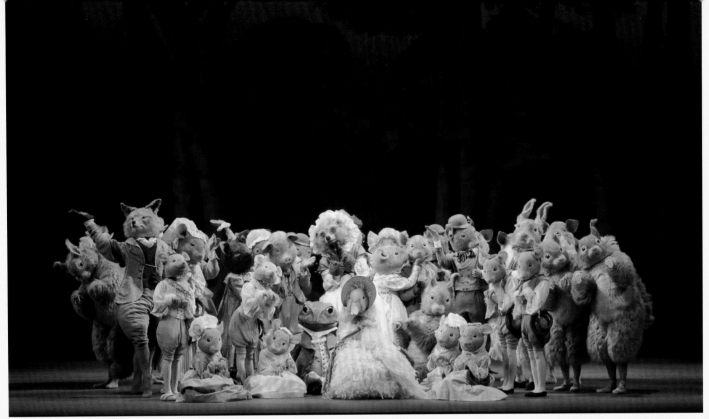

1993 7 April Company premiere of Baryshnikov's *Don Quixote*.

1994 6 April Premiere of Dowell's new production of *The Sleeping Beauty* on tour in Washington D.C.. **18 June** Premiere of Ashley Page's *Fearful Symmetries*. **3 November** UK Premiere of Dowell's production of *The Sleeping Beauty*.

1996 2 May Revival of MacMillan's *Anastasia*, with new designs by Bob Crowley.

1997 14 July Farewell Gala and final performance before the Royal Opera House closes for refurbishment. During the closure The Royal Ballet performs at the Hammersmith Apollo, the Royal Festival Hall and the Barbican.

1999 23 November The Company marks the reopening of the Royal Opera House with 'A Celebration of International Choreography'. **17 December** Opening night of *The Nutcracker*, the first full-length ballet in the new House.

2000 8 February Revival of De Valois's production of *Coppélia*, using Osbert Lancaster's original designs. **29 February** Revival of Ashton's *Marguerite and Armand*, with Sylvie Guillem and Nicolas Le Riche. **6 May** Millicent Hodson and Kenneth Archer revive Nijinsky's *Jeux* in a programme with his *L'Après-midi d'un faune*.

2001 8 March De Valois dies. **July** Ross Stretton succeeds Dowell as Director of The Royal Ballet. **30 July** *Swan Lake* is the first full-length ballet to be broadcast to Big Screens. **23 October** Premiere of Nureyev's staging of *Don Quixote*. **22 November** Company premiere of Cranko's *Onegin*.

2002 September Ross Stretton resigns as Director. **December** Monica Mason becomes Director of the Company.

2003 13 January Company premiere of Jiří Kylián's *Sinfonietta*. **8 March** Premiere of Makarova's new production of *The Sleeping Beauty*. **April** Jeanetta Laurence appointed Assistant Director. **22 December** Premiere of Wendy Ellis Somes's new production of Ashton's *Cinderella*.

2004 April The Company marks the 75th anniversary of Sergey Diaghilev's death in a programme that includes *Le Spectre de la rose*. **4 November** Revival of Ashton's full-length *Sylvia*, reconstructed and staged by Christopher Newton for the 'Ashton 100' celebrations.

2005 7 May Premiere of Christopher Bruce's *Three Songs – Two Voices*, inspired by the life of Jimi Hendrix.

2006 15 May The Company celebrates its 75th anniversary with a new production of the 1946 *The Sleeping Beauty*, realized

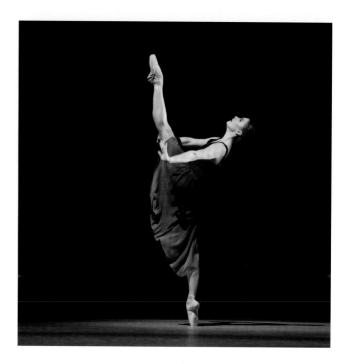

The combination of the Ashtonian elegance and MacMillan's sense of drama has always been the root of the Royal Ballet style, the template into which dancers and choreographers alike have adapted their personalities. It sustained them through the tricky decades of the 1970s and 80s, attracting international stars even when times were tough. Sylvie Guillem, one of those who was invited as a guest artist by Director Anthony Dowell, noticed the courage and commitment of the British dancers. 'In Paris, it was more athletic, more technique, more performance,' she says. 'Here it was more about the soul and what theatre represents. That is a huge tradition here.'

The drawing power of that tradition remains a lodestone for dancers from outside the Company to this day, meaning that international talents perform alongside those trained and moulded by The Royal Ballet School. This occasionally has given rise to mutterings about the preservation of style, just as the varying success of different directorial regimes and different new ballets has prompted concerns about the future of the Company. Yet history is written by the victors: it is the triumphs that are remembered not the disappointments and defeats. Ashton's *Tiresias* is all but forgotten, but *Symphonic Variations* will be danced for ever. MacMillan's *Isadora* will always be less performed than his masterly *Mayerling*.

Without the benefit of hindsight, it is sometimes difficult to judge whether the new works of today will join the credit or the debit column, though the betting has to be that contributions such as Wayne McGregor's *Chroma* and Christopher Wheeldon's *The Winter's Tale* are likely to be the classics of tomorrow.

What is certain, however, is that the instinct to keep moving forward, to try different things, is in keeping with the pioneering spirit with which De Valois started her company 85 years ago. 'Her motto was respect the past, herald the future and concentrate on the present,' remembers Peter Wright. It makes a fine motto for The Royal Ballet today.

by Monica Mason and Christopher Newton with Messel's original designs, re-created by Peter Farmer. It is followed by revivals of Ashton's *Homage to The Queen*, with additional choreography by Christopher Wheeldon, Michael Corder and David Bintley, and De Valois's *The Rake's Progress*. **8 June** HM The Queen attends a gala performance of *Homage to The Queen* with *La Valse* and divertissements. **November** Premieres of Wayne McGregor's *Chroma* and Wheeldon's *DGV: Danse à grande vitesse*. **December** McGregor becomes Resident Choreographer of The Royal Ballet.

2007 March Premiere of Alastair Marriott's *Children of Adam*. **April** Premiere of Will Tuckett's *The Seven Deadly Sins*. **June** Barry Wordsworth is appointed Music Director. **23 November** Company premiere of Balanchine's *Jewels*.

2008 28 February Premiere of Wheeldon's *Electric Counterpoint*. **23 April** Premiere of Kim Brandstrup's *Rushes – Fragments of a Lost Story*. **October** The 50th anniversary of Ashton's *Ondine*. **13 November** Premiere of McGregor's *Infra*. **28 December** *The Nutcracker* is broadcast live to cinemas around the world, in the Company's first cinema broadcast.

2009 March Anthony Russell-Roberts retires as Artistic Administrator and is succeeded by Kevin O'Hare. **April** Jeanetta Laurence is appointed Associate Director of The Royal Ballet. **17 November** Memorial service dedicated to the founders of The Royal Ballet held at Westminster Abbey.

2010 January 50th anniversary of Ashton's *La Fille mal gardée*. **5 May** Premiere of Liam Scarlett's *Asphodel Meadows*.

2011 28 February Premiere of Wheeldon's *Alice's Adventures in Wonderland*, to a commissioned score by Joby Talbot. **17–19 June** The Company appears at The O$_2$ Arena for the first time, performing MacMillan's *Romeo and Juliet*.

2012 23 March 'Royal Ballet Live', a day behind the scenes with The Royal Ballet, is broadcast live on the internet. **5 April** Premiere of McGregor's *Carbon Life* and Scarlett's *Sweet Violets*. **2 June** Revival of MacMillan's *The Prince of the Pagodas* after a 16-year absence from the Company's repertory. **15–20 June** Premiere of *Metamorphosis: Titian 2012*, a triptych of new works by Brandstrup and McGregor, Marriott and Wheeldon and Scarlett, Tuckett and Watkins, in collaboration with the National Gallery. **20 June** Mason retires as Director, succeeded by O'Hare. **July** Wheeldon is appointed Artistic Associate. **30 October**

The Company celebrates HM The Queen's Diamond Jubilee in a gala performance. **November** Scarlett is appointed the Company's first Artist in Residence.

2013 22 February Premieres of Ratmansky's *24 Preludes* and Wheeldon's *Aeternum*. **February–March** Members of the Company tour to Brazil. **8 May** Premiere of Scarlett's *Hansel and Gretel*. **24 May** Premiere of McGregor's *Raven Girl*. **20 June** Premiere of Brandstrup's *Ceremony of Innocence* at the Aldeburgh Festival. **5 October** Premiere of Carlos Acosta's production of *Don Quixote*. **9 November** Premiere of David Dawson's *The Human Seasons*.

2014 7 February Premiere of McGregor's *Tetractys*. **10 April** Premiere of Wheeldon's *The Winter's Tale*. **May** 50th anniversary of Ashton's *The Dream*. **31 May** Premiere of Marriott's *Connectome*. **June** The Company tours to the Bolshoi Theatre, Moscow, Taipei and Shanghai. **7 November** Premiere of Scarlett's *The Age of Anxiety*.

2015 7 March Premiere of Hofesh Shechter's *Untouchable*. **11 May** Premiere of McGregor's *Woolf Works*. **June** Jeanetta Laurence retires as Associate Director and Barry Wordsworth retires as Music Director; the Company tours to the USA for the first time in six years. **September** 50th anniversary of MacMillan's *Romeo and Juliet*. **26 October** Premiere of Ashton's *The Two Pigeons* after a 30-year absence from the repertory.

2016 12 March Premiere of Wheeldon's *Strapless*. **4 May** Premiere of Scarlett's *Frankenstein*. **28 June** premiere of McGregor's *Obsidian Tear* and revival of MacMillan's *The Invitation* after a 20-year absence from the repertory. **June** The Company tours to Japan. October revival of MacMillan's *Anastasia* after a 20-year absence from the repertory. **10 November** Premiere of McGregor's *Multiverse*.

2017 27 January Premiere of Javier De Frutos's *Les Enfants Terribles*. **16 March** Premiere of Crystal Pite's *Flight Pattern*. **18 May** Premiere of Scarlett's *Symphonic Dances*. **June** The Company tours to Australia, visiting Brisbane and Cairns.

This page:
(top, left to right) Royal Ballet Director Kevin O'Hare, Royal Ballet Music Director Koen Kessels, Resident Choreographer Wayne McGregor, Artistic Associate Christopher Wheeldon and Artist in Residence Liam Scarlett

(bottom, left to right) Administrative Director Heather Baxter, Rehearsal Director Christopher Saunders and Clinical Director Gregory Retter

PRINCIPALS

PRINCIPALS
Left to right:

Federico Bonelli

Alexander Campbell

Lauren Cuthbertson

Francesca Hayward

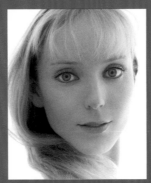
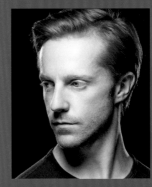

Ryoichi Hirano

Nehemiah Kish

Sarah Lamb

Steven McRae

Laura Morera

Vadim Muntagirov

Yasmine Naghdi

Marianela Nuñez

Natalia Osipova
Thiago Soares
Akane Takada
Edward Watson

PRINCIPAL CHARACTER ARTISTS, CHARACTER ARTISTS, FIRST SOLOISTS AND SOLOISTS

PRINCIPAL CHARACTER ARTISTS
Left to right:
Christina Arestis
Gary Avis
Bennet Gartside
Alastair Marriott

Elizabeth McGorian
Kristen McNally
Christopher Saunders
Thomas Whitehead

CHARACTER ARTISTS
Left to right:
Jonathan Howells
Philip Mosley

FIRST SOLOISTS
Matthew Ball
Claire Calvert

Yuhui Choe
Helen Crawford
Melissa Hamilton
James Hay

Hikaru Kobayashi
Itziar Mendizabal
Marcelino Sambé
Beatriz Stix-Brunell

Valentino Zucchetti

SOLOISTS
Left to right:
Luca Acri
William Bracewell
Reece Clarke

Olivia Cowley
Tristan Dyer
Nicol Edmonds
Benjamin Ella

Elizabeth Harrod
Tierney Heap
Meaghan Grace Hinkis
Fumi Kaneko

Paul Kay
Mayara Magri
Emma Maguire
Laura McCulloch

Fernando Montaño
Anna Rose O'Sullivan

FIRST ARTISTS
Left to right:
Tara-Brigitte Bhavnani
Camille Bracher

FIRST ARTISTS AND ARTISTS

David Donnelly
Kevin Emerton
Isabella Gasparini
Hannah Grennell

Nathalie Harrison
Tomas Mock
Erico Montes
Romany Pajdak

Demelza Parish
Gemma Pitchley-Gale
Calvin Richardson
Leticia Stock

Gina Storm-Jensen
Lara Turk
David Yudes

ARTISTS
Left to right:
Lukas Bjørneboe Brændsrød

Grace Blundell
Mica Bradbury
Annette Buvoli
Harry Churches

Ashley Dean
Leticia Dias
Leo Dixon
Téo Dubreuil

Chisato Katsura
Isabel Lubach
Julia Roscoe
Giacomo Rovero

Mariko Sasaki
Francisco Serrano
Joseph Sissens
Charlotte Tonkinson

AUD JEBSEN YOUNG DANCERS
Left to right:

Joonhyuk Jun
Joshua Junker
Sae Maeda
Nadia Mullova-Barley

Aiden O'Brien
Amelia Palmiero

PRIX DE LAUSANNE DANCER

Stanisław Węgrzyn

ROYAL BALLET STAFF

Ballet Masters
Gary Avis
Ricardo Cervera
Jonathan Howells

Ballet Mistress
Samantha Raine

Assistant Ballet Mistress
Sian Murphy

*Senior Teacher and Répétiteur
to the Principal Artists*
Alexander Agadzhanov

Répétiteurs
Lesley Collier
Jonathan Cope

*Guest Principal
Ballet Master*
Christopher Carr

Principal Guest Répétiteur
Carlos Acosta

Principal Guest
Teachers
Elizabeth Anderton
Olga Evreinoff

Senior Benesh Notator
Anna Trevien

Benesh Notator
Gregory Mislin
Lorraine Gregory

Principal Guest Conductor
Barry Wordsworth

Head of Music Staff
Robert Clark

*Learning and Participation
Creative Associate (Ballet)*
David Pickering

*Ballet Rehabilitation Specialist
and Class Teacher*
Brian Maloney

Artistic Scheduling Manager
Philip Mosley

Company and Tour Manager
Rachel Vickers

Senior Producer
Emma Southworth

Artistic Administrator
Rachel Hollings

Stage Manager
Johanna Adams Farley

Head of Ballet Press
Ashley Woodfield

The Royal Ballet

Patron **HM The Queen**
President **HRH The Prince of Wales**
Vice-President **The Lady Sarah Chatto**

Director[†] **Kevin O'Hare**
Music Director **Koen Kessels**

Resident Choreographer[‡] **Wayne McGregor** CBE
Artistic Associate[††] **Christopher Wheeldon** OBE

Principals
Roberto Bolle*
Federico Bonelli
Alexander Campbell
Lauren Cuthbertson
Alessandra Ferri*
David Hallberg*
Francesca Hayward
Ryoichi Hirano
Nehemiah Kish
Sarah Lamb
Steven McRae
Laura Morera
Vadim Muntagirov
Yasmine Naghdi
Marianela Nuñez
Natalia Osipova
Vladimir Shklyarov*
Thiago Soares
Akane Takada
Edward Watson

Principal Character Artists
Christina Arestis
Gary Avis
Bennet Gartside
Alastair Marriott
Elizabeth McGorian
Kristen McNally
Christopher Saunders
Thomas Whitehead

Character Artists
Philp Mosley
Jonathan Howells

First Soloists
Matthew Ball
Claire Calvert
Yuhui Choe
Helen Crawford
Melissa Hamilton
James Hay
Hikaru Kobayashi
Itziar Mendizabal
Marcelino Sambé
Beatriz Stix-Brunell
Valentino Zucchetti

Soloists
Luca Acri
William Bracewell
Reece Clarke
Olivia Cowley
Tristan Dyer
Nicol Edmonds
Benjamin Ella
Elizabeth Harrod
Tierney Heap

Meaghan Grace Hinkis
Fumi Kaneko
Paul Kay
Mayara Magri
Emma Maguire
Laura McCulloch
Fernando Montaño
Anna Rose O'Sullivan

First Artists
Tara-Brigitte Bhavnani
Camille Bracher
David Donnelly
Kevin Emerton
Isabella Gasparini
Hannah Grennell
Nathalie Harrison
Tomas Mock
Erico Montes
Romany Pajdak
Demelza Parish
Gemma Pitchley-Gale
Calvin Richardson
Leticia Stock
Gina Storm-Jensen
Lara Turk
David Yudes

Artists
Lukas Bjørneboe Brændsrød
Grace Blundell
Mica Bradbury
Annette Buvoli
Harry Churches
Ashley Dean
Leticia Dias
Leo Dixon
Téo Dubreuil
Chisato Katsura
Isabel Lubach
Julia Roscoe
Giacomo Rovero
Mariko Sasaki
Francisco Serrano
Joseph Sissens
Charlotte Tonkinson

Aud Jebsen Young Dancers Programme
Joonhyuk Jun
Joshua Junker
Sae Maeda
Nadia Mullova-Barley
Aiden O'Brien
Amelia Palmiero

Prix de Lausanne dancer
Stanisław Węgrzyn

*Guest Artist

Rehearsal Director
Christopher Saunders

Ballet Masters
Gary Avis
Ricardo Cervera

Ballet Master and Character Artist
Jonathan Howells

Ballet Mistress
Samantha Raine

Assistant Ballet Mistress
Sian Murphy

Senior Teacher and Répétiteur to the Principal Artists
Alexander Agadzhanov

Répétiteurs
Lesley Collier
Jonathan Cope

Senior Benesh Notator
Anna Trevien

Benesh Notators
Gregory Mislin
Lorraine Gregory

Learning and Participation Creative Associate (Ballet)
David Pickering

Artist in Residence
Liam Scarlett

Young Choreographer Programme
Charlotte Edmonds

Head of Music Staff
Robert Clark

Music Staff
Philip Cornfield
Craig Edwards
Grant Green
Michael Pansters
Tim Qualtrough
Kate Shipway
Paul Stobart

Music Administrator
Nigel Bates

Senior Producer
Emma Southworth

Producer
Hannah Mayhew

Assistant to the Producers
Adrienne Miller

Video Archive Manager
Bennet Gartside

Stage Manager
Johanna Adams Farley

Head of Ballet Press
Ashley Woodfield

Administrative Director
Heather Baxter

Company and Tour Manager
Rachel Vickers

Artistic Scheduling Manager
Philip Mosley

Artistic Administrator
Rachel Hollings

Financial Controller
Cathy Helweg

Deputy Company Manager
Elizabeth Ferguson

Assistant to the Director
Lettie Heywood

Administrative Co-ordinator
Yvonne Hunte

Management Accountant
Orsola Ricciardelli

Contracts Administrator
Sarah Quarman-Rose

Assistant Producer
Rhiannon Savell

Clinical Director, Ballet Healthcare
Gregory Retter

Clinical Lead
Caryl Becker

Chartered Physiotherapists
Gemma Hilton
Moira McCormack
Robin Vellosa

Pilates Instructor
Jane Paris

Gyrotonic Instructor
Fiona Kleckham

Occupational Psychologist
Britt Tajet-Foxell

Ballet Rehabilitation Specialist and Class Teacher
Brian Maloney

Ballet Rehabilitation Coach
Ursula Hageli

Ballet Masseurs
Tatina Semprini
Konrad Simpson
Helen Wellington

Sports Science
Austin Flood
Adam Mattiussi
Gregor Rosenkranz

Registered Dietician
Jacqueline Birtwisle

Medical Advisor
Ian Beasley

Company Podiatrist
Denzil Trebilcock

Healthcare Co-ordinator
Erin Salisbury

Guest Principal Ballet Master
Christopher Carr

Principal Guest Répétiteur[†††]
Carlos Acosta

Principal Guest Teachers
Elizabeth Anderton
Olga Evreinoff

Guest Teachers
Boris Akimov
Jacquelin Barrett
Darcey Bussell
Deirdre Chapman
Felipe Diaz
Johnny Eliasen
Valeri Hristov
Andrey Klemm
David Makhateli
Laurent Novis
Alessandra Pasquali
David Peden
François Petit
Stephane Phavorin
Roland Price
Matz Skoog

Principal Guest Conductor
Barry Wordsworth

Conductors
Simon Hewett
Paul Murphy
Valery Ovsyanikov
Alondra de la Parra
Tom Seligman
Martin Yates

Governors of the Royal Ballet Companies
Chairman
Dame Jenny Abramsky DBE

Leanne Benjamin AM OBE
Professor Michael Clarke CBE DL
Ricki Gail Conway
The Lady Deighton
Stephen Jefferies
Sir David Normington GCB
Christopher Nourse
Derek Purnell
Ian Taylor
The Duchess of Wellington OBE
Monica Zamora

Honorary Secretary
Peter Wilson

In **1956** Queen Elizabeth II granted the then Sadler's Wells Ballet, Sadler's Wells Theatre Ballet and Sadler's Wells School a Royal Charter, and they became respectively The Royal Ballet and Royal Ballet School. Under the Charter a body of Governors was set up whose ultimate duty it is to safeguard the future of the Company (now The Royal Ballet and Birmingham Royal Ballet) and School and to be the custodians of the traditions established by Dame Ninette de Valois in the formation of the Company and School in 1931.

[†] Position generously supported by Lady Ashcroft [‡] Position generously supported by Linda and Philip Harley
[††] Position generously supported by Kenneth and Susan Green [†††] Position generously supported by Aud Jebsen